In Memory Of

ELEANOR W. LEHFELDT

2009

Donated By

ARLENE & ED DRENNAN

Pumpkin Decorating

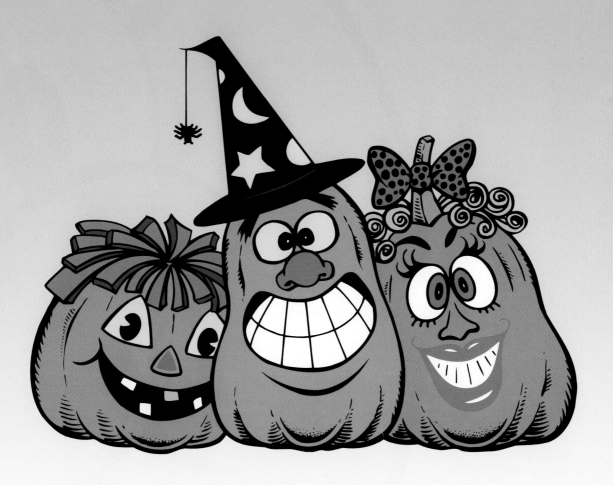

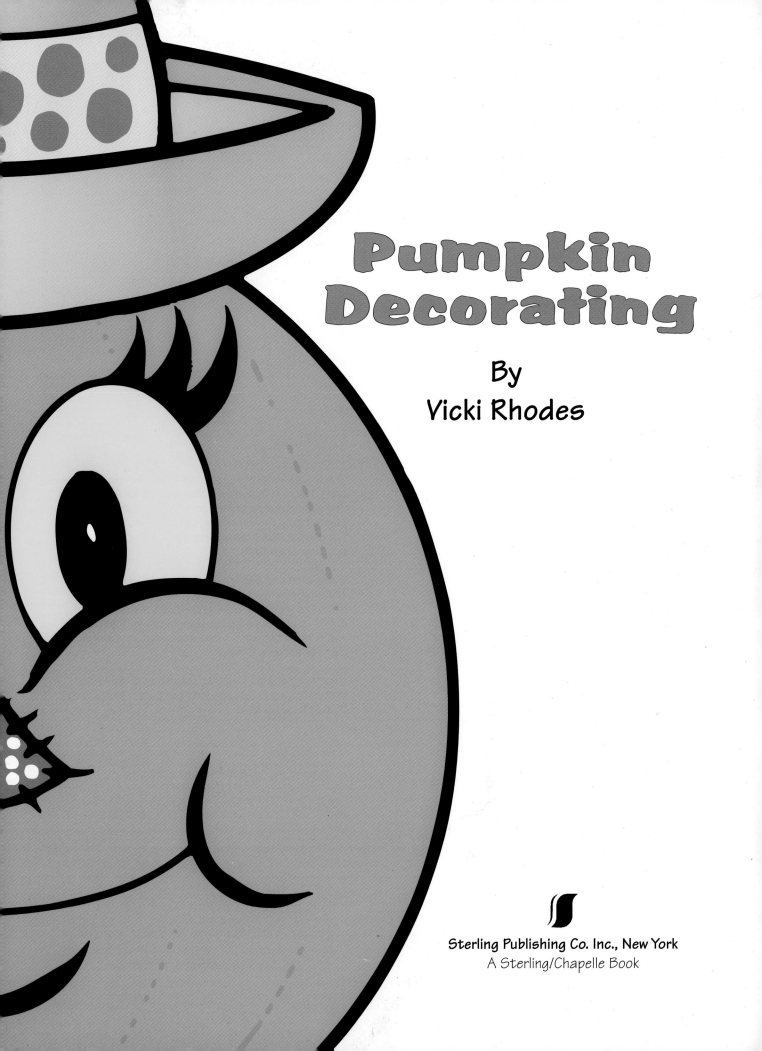

Pumpkin Decorating

By
Vicki Rhodes

Sterling Publishing Co. Inc., New York
A Sterling/Chapelle Book

Chapelle Ltd.

Owner:
Jo Packham

Editor:
Gerry De Soto

Designers:
Amber Hansen, Kathy Frongner, Phillip Romero
Susan Laws, Kelly Henderson

Staff:
Marie Barber, Malissa Boatwright, Kass Burchett, Rebecca Christensen, Holly Fuller, Marilyn Goff,
Michael Hannah, Shirley Heslop, Holly Hollingsworth, Susan Jorgensen, Pauline Locke, Barbara Milburn,
Linda Orton, Karmen Quinney, Leslie Ridenour, and Cindy Stoeckl

Photography:
Kevin Dilley, photographer for Hazen Photography

Photo Stylists:
Susan Laws and Cindy Rooks

A special thanks to Lyle Dabb Produce

Library of Congress Cataloging-in-Publication Data
Rhodes, Vicki.
 Pumpkin decorating / by Vicki Rhodes.
 p. cm.
 "A Sterling/Chapelle book."
 Includes index.
 ISBN 0-8069-9574-2
 1. Halloween decorations. 2. Jack-o-lanterns.
 3. Acrylic painting. I. Title.
 TT900.H32R46 1997
 745.594'1--dc21
 97-1936
 CIP
10 9 8 7 6 5 4 3 2 1

A Sterling/Chapelle Book

Published by Sterling Publishing Company, Inc.
387 Park Avenue South, New York, NY 10016
© 1997 by Chapelle Ltd.
Distributed in Canada by Sterling Publishing
c/o Canadian Manda Group, One Atlantic Avenue, Suite 105
Toronto, Ontario, Canada M6K 3E7
Distributed in Great Britain and Europe by Cassell PLC
Wellington House, 125 Strand, London WC2R 0BB, England
Distributed in Australia by Capricorn Link (Australia) Pty Ltd.
P.O. Box 6651, Baulkham Hills, Business Centre, NSW
2153, Australia
Printed and bound in Hong Kong
All Rights Reserved

Sterling ISBN 0-8069-9574-2 Paper
 0-8069-9575-0 Trade

If you have any questions or comments or would like information about any specialty products featured in this book, please contact:

Chapelle Ltd., Inc.
P.O. Box 9252
Ogden, UT 84409

Phone: (801) 621-2777
FAX: (801) 621-2788

The author wishes to express her sincere appreciation to Chroma Acrylics, Inc. for providing the Jo Sonja line of products used in this publication.

Vicki L. Rhodes

I have been involved with some sort of painting for over 25 years. I and my family grew up with painting as part of our lives. More common than place settings on our kitchen table were numerous painting projects.

My first painting endeavors were in my mother's ceramics shop where I worked and painted alongside my mother. My son and little helper, Kirby, who had his own room in which to nap and play, worked right along with us and painted many special gifts for family members. When my second helper, Shelby, arrived, my parents were temporarily living in Florida and I was running the business by myself. Shelby was too busy getting into everything to allow me to take care of the shop so we sold it. But, unable to give up painting, I would often paint at home, sitting cross-legged on the floor with my son in my lap.

I started tole painting with a book and oil paints. I was hooked! I began teaching to support my habit and also took classes to satisfy my desire to learn and improve. After frustration and tears, I switched to acrylics - I was not going to let oil paints get the best of me!

I have been truly blessed by the wonderful friends and teachers who have shared their experiences and knowledge with me. The biggest change in my painting career came after taking a class with Jo Sonja Jansen in Eureka, California, where I was introduced to the Jo Sonja products. The paints, mixed with the various Jo Sonja mediums, offered incredible versatility. From then on my painting blossomed into a joyous adventure! It is such a compliment to have someone appreciate my work; just like a hug! I love to see the smiles that surface when someone enjoys what I have created. After all, it is a part of me. Time spent making something fun or beautiful brings such joy!

The designs in this book are just a starting point for your own creative adventure! Do not become frustrated if your painting does not look just like mine. I say, "That's wonderful! Take these things and make them yours!"

TABLE OF
CONTENTS

THE GOURD FAMILY

Pumpkins are part of the gourd family, as are melons and squash. Pumpkins, melons and squash are considered to be fruit.

All gourds have thick, tough skins. Painting, carving, and embellishing can be done in the same manner on any variety.

Gourds are grown in several colors, including various shades of orange, yellow, green, brown, and white. Try picking a gourd in a color that will eventually be the background color for the chosen artwork. This will eliminate the need for a base coat.

Because of the unusual shapes of many gourds, a pumpkin turned on its side can utilize the stem as part of the design.

Because of the varying sizes of gourds (especially pumpkins!), the patterns provided can be adapted easily to fit any size. Once a determination has been made regarding the general size of the gourd to be used, an enlarged or a reduced photo copy of the pattern can be made.

CHOOSING THE PERFECT PUMPKIN

When using a fresh pumpkin for painting, choosing one that will suit the chosen pattern. When choosing one for carving, it is important that the complexity of the design be taken into consideration. Match more difficult designs to large, smooth, and/or flat pumpkins.

Always use fresh pumpkins that are free from bruises. Never purchase a pumpkin that does not have a stem. Once a stem has been broken off, the pumpkin will not last long. If a pumpkin can be chosen and picked from the vine, try to leave two to three inches of

vine on the stem. This will allow the pumpkin to stay fresh longer.

Remember that once a pumpkin has been carved, its life expectancy is only two to five days.

EXTENDING THE LIFE OF THE PUMPKIN

Pumpkins are considered seasonal fruit and, therefore, fresh ones cannot be found year around. Fresh pumpkins can be stored for several months under controlled conditions. They must always be kept dry and cool, and must not be allowed to freeze. When storing pumpkins, keep space around each pumpkin so that air can circulate. Never stack them - if one should get a rotten spot, it could infect the entire pile!

If the pumpkin dries out a little, it can be revived by soaking it in water for two to eight hours, then thoroughly drying.

In case fresh pumpkins cannot be found, the general instructions also include tips for painting on plastic pumpkins, compressed styrofoam pumpkins, papier-mâché pumpkins, and pumpkins made from wood.

GENERAL INSTRUCTIONS FOR
PUMPKIN CARVING

Pumpkin carving has been enjoyed for many, many years. A painted or decorated pumpkin can also be accented with carved sections. Some of the painting patterns provided also can be used as patterns for simple carvings!

PREPARING PUMPKINS FOR CARVING

Cut an opening in the pumpkin using a large, sharp knife. Cut out the top for a lid or cut out the bottom. Cut the lid out at an angle. This provides a ledge for the lid to rest on. For easy alignment, cut a "key" in the lid so replacing the lid is simpler.

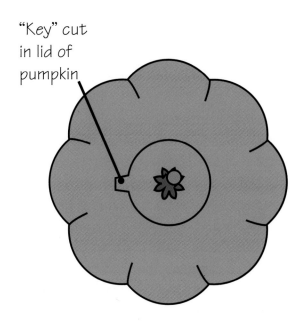

"Key" cut in lid of pumpkin

It is recommended that lids on smaller pumpkins (less than 10" diameter) measure approximately 4" in diameter and lids on larger pumpkins (more than 10" diameter) measure approximately 6" to 8" in diameter.

Once an opening has been cut, clean out seeds and the inside membrane. Scrape out the inside lining of the pumpkin until the walls are approximately 1" thick.

TOOLS NEEDED FOR PUMPKIN CARVING

Few tools are needed for carving pumpkins, but they are important. A poking tool is used for transferring patterns, a pumpkin drill is used for making holes (such as eyes), and a saw tool is used for the actual carving. A large, sharp knife is needed to cut an opening in the pumpkin and a scraping tool makes cleaning out the pumpkin cavity easier.

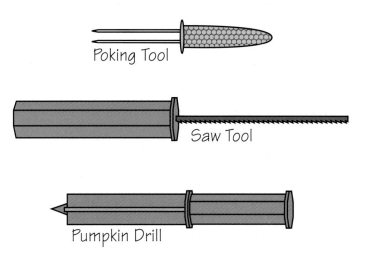

Poking Tool

Saw Tool

Pumpkin Drill

TRANSFERRING PATTERNS ONTO PUMPKINS

The pattern must first be adapted to a size that will work with the size of pumpkin being used. A photo copy, enlarged or reduced appropriately, is the easiest way to assure the design will be in proportion to the size of the pumpkin. Transferring the pattern (see page 11) onto the chosen pumpkin can be done by first aligning the design in the proper position on the surface of the pumpkin. To allow the pattern to lie snugly on the round surface of the pumpkin, make cuts from the

corners of the pattern toward the center and tape it into position.

The pattern can also be pinned to the pumpkin's surface, but to avoid unnecessary holes on the surface, it is recommended that the pins be placed in the center of the pattern or in the grooves on the pumpkin.

Once the pattern is in position, carefully punch holes along the outside of the pattern using a poking tool. Do not attempt to poke all the way through the pumpkin, just puncture the surface. For simpler designs, place the holes approximately 1/16" to 1/8" apart. If the designs are more intricate, holes are closer together. Once all the lines have been transferred, remove the pattern. If the "punched pattern" cannot easily be seen, dust the dots with flour.

DRILLING HOLES & CARVING

• DRILLING HOLES

Before carving the design, drill holes as necessary for eyes and other small, round details using a pumpkin drill. Drilling requires applying pressure to be applied to the pumpkin; it must be done prior to carving. If not, the drilling process could break the design in areas that have been weakened by carving.

• CARVING

To carve the design, use a saw tool to gently, but firmly, puncture the surface of the pumpkin. Once the saw tool has been inserted straight into the pumpkin, begin to saw from "dot to dot" at a 90° angle. Start carving from the center of the design and work outward. Do not twist or bend the saw tool; the blade could break.

The trick to perfect carving is patience. Once the carving is complete and all pieces are completely cut loose, use the eraser end of a pencil to gently push the carved pieces out. If a mistake should happen, try pinning the piece back in place using toothpicks or pins.

CANDLE LIGHTING THE CARVED PUMPKIN

Rub vegetable oil or petroleum jelly onto freshly cut areas of the pumpkin to help delay aging. If possible, carve the pumpkin the day before it is to be displayed.

Cut a 1"- diameter hole in the top of the pumpkin over the candle to act as a chimney. This allows the air to circulate around the candle and will also prevent the candle from producing excess smoke. Pumpkins with smoke chimneys last longer because the heat can escape. Those that do not have chimneys will actually begin to bake from the inside out.

Place a candle inside, near the rear of the pumpkin on top of a piece of aluminum foil. When the candle is in position, carefully light it.

If no lid was cut out and the opening is in the bottom of the pumpkin, mount a candle on a cut piece of pumpkin, or place one in a household candle holder, or on a metal jar lid. Light the candle and then place the pumpkin over it.

If living in climates that get extremely cold (near freezing) at night or warmer than 60°F (15°C) in the day, bring the pumpkin inside to prolong its enjoyability!

GENERAL INSTRUCTIONS FOR PUMPKIN PAINTING

The idea of painting on pumpkins is relatively new, it has allowed pumpkins to be used as a new art form.

PREPARING FRESH PUMPKINS FOR PAINTING

Because of the nature in which pumpkins are generally purchased, fresh pumpkins should be thoroughly washed and dried before patterns are transferred onto them.

BASE-COATING ALL PUMPKINS

Sometimes a pumpkin will be painted with a design and the background will be left as the unpainted surface of the pumpkin. In some cases, the pattern requires that the entire pumpkin surface be painted. Acrylic paints have been used on the projects in this book and the number of coats necessary will be determined primarily by the base-coat color being used. If available, spray paint can also be used to base-coat pumpkins.

When fresh pumpkins are being used, a paint sealer should be used on the entire pumpkin surface before acrylic paint is applied. This will help adhere the paint to the surface. If a paint sealer is not used, paint can easily chip off. Because the surfaces of plastic, compressed styrofoam, papier mâché, and wooden pumpkins are rough and/or porous, a layer of paint sealer is not usually necessary.

TRANSFERRING PATTERNS ONTO PUMPKINS

The pattern must first be adapted to a size that will work with the size of pumpkin being used. A photo copy, enlarged or reduced appropriately, is the easiest way to assure the design will be in proportion to the size of the chosen pumpkin. If all the colors in the pattern are dark, a color copy may be necessary to get the line definition needed for pattern transferring. To allow the pattern to lie snugly on the round surface of the pumpkin, make cuts from the corners of the pattern toward the center and tape it into position.

• METHOD ONE

The pattern in the book can be traced onto tracing paper and then transferred onto the pumpkin using graphite paper. Place the graphite paper between the pattern and the pumpkin with the graphite side facing the pumpkin. Tape the graphite paper and the pattern into position. Carefully, but firmly, trace the pattern using a pencil. Lift the corner slightly to make certain the pattern is transferring nicely. Once the design has been transferred, remove the pattern and the graphite paper.

• METHOD TWO

Make a photo copy of the pattern in the appropriate size and cut it out. Place it on the pumpkin and tape into position. Carefully trace around the pattern. When using a fresh pumpkin, use a dull pencil or a blunt object and press hard enough to make a slight indentation on the pumpkin's surface, but be very careful to not puncture it. Once the design has been transferred, remove the pattern.

PAINTBRUSHES & SPONGES

Paintbrushes are the most common tools used for painting pumpkins. Good quality synthetic brushes work best when using acrylic paints. Sponges should be used when sponge painting and can be found in many different sizes and textures.

A variety of different sized paintbrushes are recommended - the size of the brush will depend upon the size of the pattern you are painting. Small, liner brushes are used for detailing and large, flat brushes are used for painting larger areas, such as base-coating. Flat chisel blenders, scrollers, and shaders might also come in handy, but are not mandatory.

TYPES OF BRUSHES

Each brush has its own special purpose in painting. When you know which brush to use, painting is easy. Drawing #1 shows the various types of brushes that are used in painting and detailing pumpkins.

Drawing #1

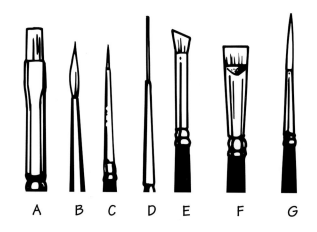

A-Flat brush brush
B-Round decorative
C-Short bristle round scroller brush
D-Script liner or scroller brush
E-Deerfoot brush
F-Fabric painting brush, flat scrubber brush
G-Fabric brush liner

• FLAT BRUSHES

Brush "A" in the drawing is a flat synthetic bristle brush with bristles which come to a fine chisel (narrow) edge. Sometimes this chisel edge is used to make fine lines. More often, the flat brushes are used to base in (to colorbook paint) a given area. Use the largest flat brush you can handle in any given area. In other words, use a small #4 flat to base in a small violet petal and use a large #8 brush to base in a large heart. In this way a given area can be filled in with as few strokes as possible.

Flat brushes are also used in floating color; this is done easily with the brush that has a wide chisel edge. Because the bristles are long, they can carry a lot of paint so stops do not have to be made as often to reload the brush.

The flat brush also allows beautiful stroke work since it can go from the skinny chisel edge and flow right into the full width of the brush.

• ROUND BRUSHES

Brush "B" in the drawing serves an entirely different purpose from flats in painting. A round decorative brush can get into tiny areas that would be very difficult to do with a flat brush. In this instance, they can be used for basing in paint. They are also very good for doing stroke work. There are two types of speciality round brushes that are also used for these projects - liner brushes and a scroller.

• LINERS

Brush "C" in the drawing is a short bristle round scroller brush or liner brush. It is used mostly for round-ended strokes. It may also be flattened out to

make a very small flat brush and is some-times used to base in very small areas or to paint a ribbon. Tiny dots are also done with the small round brush.

• SCRIPT LINER OR SCROLLER

Brush "D" in the drawing is a long-bristle round scroller brush, usually used to make fine lines or tendrils around flowers. When using this brush, thin the paint with a little water to make it flow easily off the brush.

• DEERFOOT BRUSH

Brush "E" in the drawing is a deerfoot brush which is used for painting fur, foliage, lace edges, and other similar "textured looking" areas. This is a fat round brush that is cut on an angle across the bottom. Use the longest bristles to nibble into the outside edge of the paint puddle when loading this brush.

• FABRIC PAINTING BRUSHES

Brush "F" in the drawing is a #5 fabric brush flat scrubber that scrubs the paint into the fabric when basing in the design. Brush "G" is a #1 liner used to do the detail work of the design.

• BRUSH CLEANING

Cleaner and Conditioner can be used to thoroughly clean a brush befor stor-age. It can also be used on hands and palettes. To clean the brush when they have wet paint in them, work the cleaner into the bristles on a clean area of pal-ette until the paint has loosened. Add small amounts of water as needed to create a lather. Rinse the brush thor-oughly in cool water until no lather ap-pears. If there is dried paint in the bristles, dip the brush in the cleaner and work the solution into the bristles on a

clean area of the palette. Add small amounts of water to create a lather. Set the brush aside for 15 to 20 minutes. Repeat if necessary. Then rinse in cool water. When brushes have been thoroughly cleaned, store them with the bristle ends up.

BASIC TOLE PAINTING TECHNIQUES

• SOLID BASE COATING

Apply two to three coats of acrylic paint. This will give the best coverage and an even look to the paint.

• BASE COATING WASH

When base-coating with a "wash," add water to the acrylic paint to achieve a sheer color. The amount of water used will determine the value of the color. Load brush with wash. Touch corner of brush on wet paper towel to remove excess water. When applying a wash, work as quickly as possible, using long, even strokes, but do not overlap.

• SPONGE PAINTING

Load the top of a sponge with paint. Blot the sponge on a paper towel until most of the paint has been removed. Apply the paint to the pumpkin by lightly "blotting" the sponge up and down. Work in a circular motion starting at the center of the pumpkin.

• HIGHLIGHTING AND SHADING

Dip a flat brush in water, then re-move the excess water from the brush by blotting it on a paper towel. Apply acrylic paint to the side of the flat brush and blend, staying in one track, until the paint fades evenly across the brush. The paint will fade from dark to light.

• STIPPLING

Load a dry round fabric brush or stipple brush with paint. Use very little paint. Bounce brush on paper towel to remove excess paint, then apply lightly. Vary dot sizes to create shadow or texture effect.

• DOTS

Use a round object; such as the end of a paintbrush, stylus, or corsage pin. Dip in paint, then on project. For uniform dots load brush each time a dot is made. For descending dots, load the brush then start "dotting" until they get smaller and smaller. Create small dots by using a liner brush and rolling it to a point. For hearts create two dots side by side, and then drag the brush or stylus through the dots making the point of the heart.

• SPATTERING

To apply speckles to the surface, select an old toothbrush or similar stiff bristled brush. Thin the paint with water, load the brush and rub the bristles across the edge of a palette knife. The thinner the paint the larger the dots or speckles.

• COMMA STROKES

Use a round brush to create a dot. Rotate and decrease pressure as the tail of the comma or tear is created.

• SLIP-SLAPPING

Load a flat brush with paint using a swift criss-cross motion.

• DRY BRUSHING

Dip a flat brush in a small amount of acrylic paint. Remove the excess paint from the brush by working in a criss-cross motion on a paper towel. Using the same motion, lightly apply the paint to the pumpkin.

• OUTLINING

Painters with a great deal of detail painting experience most generally opt to detail paint using a liner brush. Painters with little or no experience will want to use a fine or medium-point permanent marker.

When using a liner brush, load in paint thinned with water. Pull the brush through the paint, turning to get a fine point. Hold the brush perpendicular to the work and line the desired areas. The thickness of the line will be determined by the amount of pressure applied to the brush.

• DETAIL PAINTING

The experience of the painter usually determines how the pumpkin will be detailed and outlined.

CRACKLE MEDIUM

Apply a base coat of one to two coats using either purple or dark blue. When dry apply an even coat of crackle medium and allow to dry thoroughly. Apply a coat of the contrasting color vermillion and yellow light 1:1. Do NOT apply paint too thickly. It will have more crackle if the paint is thinner.

PAINTING ON GLASS

To paint on glass apply primer to a clean surface using a soft, dry brush. Allow to evaporate. Then using a palette knife, thoroughly mix one part paint to three parts Glass and Tile Medium. Allow to stand for three to five minutes. Paint will be quite transparent, so several coats may be necessary. This medium is used in the brush for

floated color. Paint will be cured after one to two weeks under normal conditions. Where possible, curing may be accelerated by heating with a hot blow dryer or baking in a 330°F (165°C) oven for 30-45 minutes. A test piece is recommended to ensure correct temperature to prevent color shifting or scorching. Clean up with mild soap and water.

VARNISHING

Apply varnish with a clean, soft brush, using a slip-slap motion and a medium application. The first coat may have a tendency to pull apart and act as though it does not want to stick. Work it with the brush and the slip-slap motion until it adheres and starts to dry. Reload brush and move onto another area until the entire piece is covered. Let dry and recoat three times. This finish, after reaching cure (two weeks), is alcohol resistant.

SEALING THE ARTWORK

After the artwork is complete and the paint is completely dry, it is recommended that an acrylic spray sealer be used to set the paint and protect the artwork. Either matte sealer or gloss sealer can be used depending on the look that is desired.

TIN PIECES

For maximum adhesion and texture, add texture paste 1:1 with the base color of vermillion and yellow light mixed 1:1. Use a large soft bristle brush and a slip-slap motion. It is best to do several light coats, building the layers. Let dry well before continuing; at least 24 hours. This makes a wonderful texture for dry brushing!

SEALING TIN PIECES

The tin pieces, for maximum durability, should be varnished with several coats of

polyurethane water based gloss finish varnish. It will provide a protective finish of exceptional toughness. Clean up using soap and cool water.

• DRYING

Always allow acrylic paints to dry thoroughly before applying additional coats or colors. When a quicker drying time is necessary, a blow dryer can be used to aid in drying the paint. If paint gets too hot it may bubble and peal.

• MIXING COLORS

If mixing colors is necessary to get a perfect shade, mix a sufficient amount to complete the project. Excess paint can be stored in airtight containers.

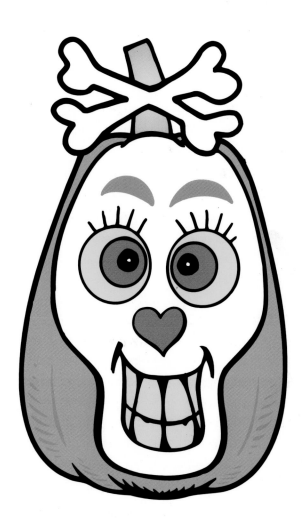

GENERAL INSTRUCTIONS FOR
PUMPKIN EMBELLISHING

Pumpkin embellishing adds interest to any painted or carved pumpkin. In many cases, embellishing is the final, finishing touch that brings the creation to life. Embellishments can also be used on pumpkins that have not been painted or carved!

ADHESIVES USED FOR EMBELLISHING

Many types of adhesives can be used to adhere embellishments to real or hand made pumpkins: hot glue gun and glue sticks, craft glue, and industrial-strength glue.

Hot glue is the most common adhesive used in this book; however, it can be substituted with other types of adhesive. If a pumpkin is going to be displayed outdoors where the temperature is cold, hot glue is not recommended and should be substituted with industrial-strength glue. However, if a pumpkin is going to be displayed indoors, hot glue is a good choice.

Plastic pumpkins are manufactured from different types of plastic and in varying thicknesses. Because of this, it is recommended that hot glue not be used on plastic pumpkins. The plastic could possibly melt from the heat of the glue.

If a pumpkin has been sprayed with a product that does not allow adhesives to adhere properly, straight pins can be used to secure embellishments in place.

MATERIALS USED FOR HAIR

Most pumpkins are painted or carved with a "face" and therefore lend themselves to hair styles that add personality and character.

Make hair from actual wigs and wiglets, doll hair, curly yarn, fake fur, crinkled paper-grass, fabric strips, curling ribbon, straw, wire, and polyester stuffing and feathers. All of these choices are available in several different colors. Polyester stuffing can be spray-painted with any color!

USING CRAFT FOAM SHEETS

Craft foam is available in many different colors and is a great medium for embellishing. It can be cut into any shape and easily glued to pumpkins. If the craft foam shapes are not as secure as needed, straight pins can be used to help secure the pieces in place. Craft foam can be highlighted with acrylic paints.

MAKING EARS AND ANTENNAE

Make antennae easily using wire or pipe cleaners and styrofoam balls or beads.

The easiest way to make ears is to cut felt fabric into triangles and simply hot-glue them into place on top of the pumpkin.

Ears can also be made by using wire bent into any shape and size. The wire can be left uncovered or can be covered with any type of fabric by cutting the fabric to size and gluing it to the fronts and backs of the shaped wire ears. Poke the wire ends into the top of the pumpkin and shape as desired.

FABRIC STIFFENER

All-purpose sealer is used to stiffen and give added body to fabric. Cut the desired shape out of fabric larger than the final size. Lay down freezer paper with the shiny side up. Thin the all-purpose sealer with either water or flow medium 2:1. Using a soft bristle brush, apply a thick coat that saturates the back of the fabric. Allow to dry completely. Peel off of the freezer paper and cut to the desired size. Fabric should have an even sheen on the BACK side. Clean up with soap and cool water.

Pumpkin Decorating Ideas

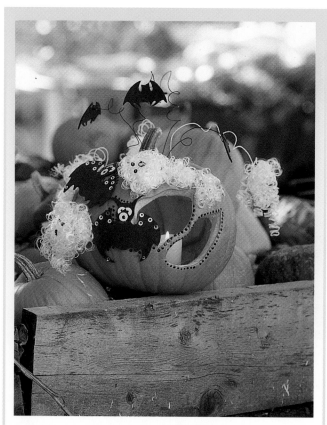

Bats and Ghosts
Refer to page 48

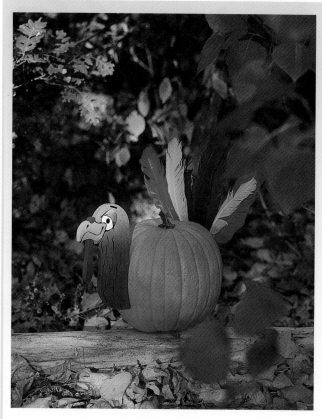

Turkey
Refer to page 48

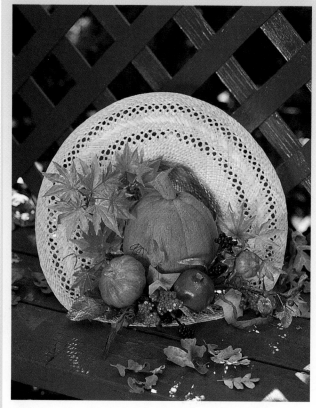

Bountiful Harvest • Vicki Rhodes
Refer to page 49

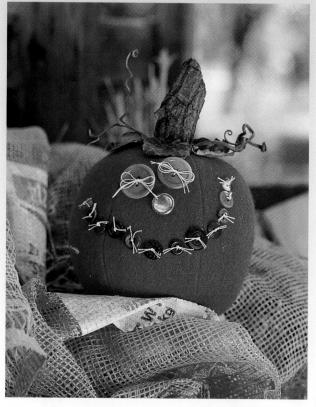

Button Punkin' • Vicki Rhodes
Refer to page 49

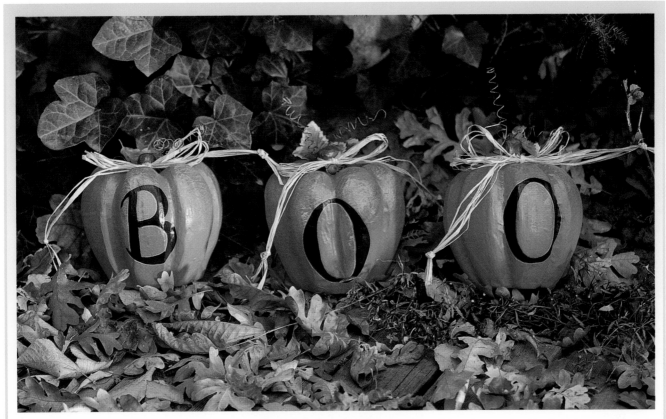

B-O-O! • Vicki Rhodes
Refer to page 50

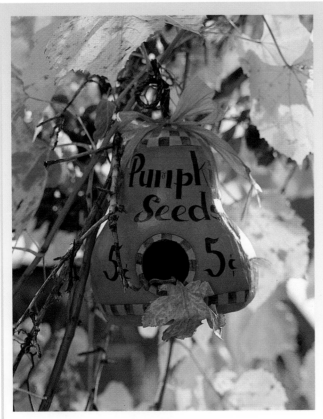

Birdhouse • Vicki Rhodes
Refer to page 50

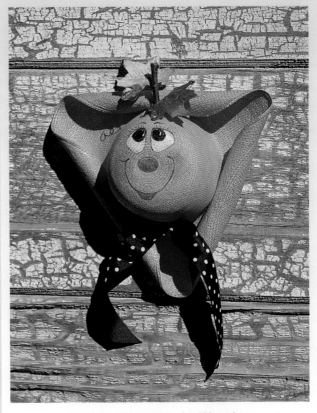

Straw Hat • Vicki Rhodes
Refer to page 51

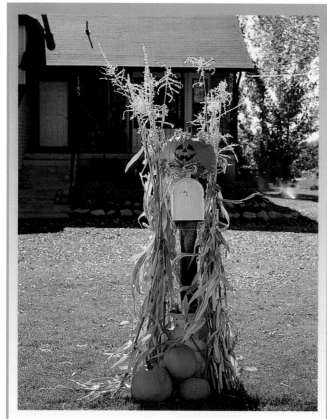

Leaves on a Pumpkin
Refer to page 51

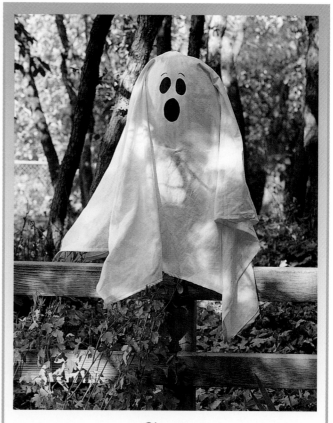

Ghost
Refer to page 52

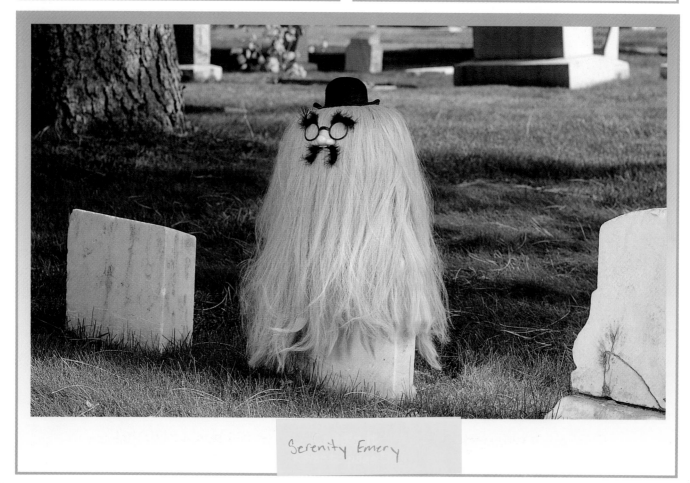

Serenity Emery

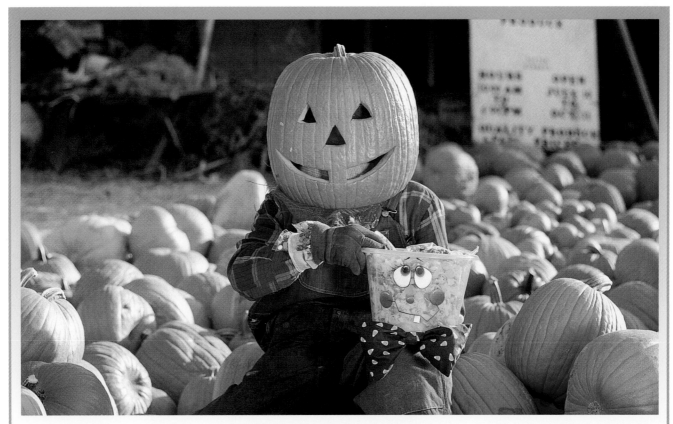

Dressed to Fill • Vicki Rhodes
Refer to page 53

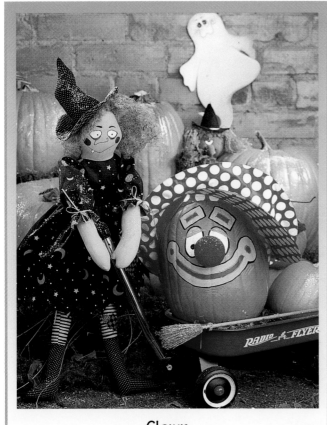

Clown
Refer to page 52

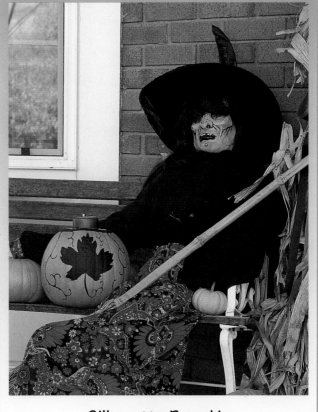

Silhouette Pumpkin
Refer to page 54

Snider the Spider • Vicki Rhodes
Refer to page 55

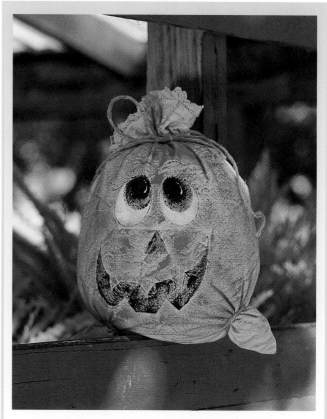

Bagged Pumpkin • Vicki Rhodes
Refer to page 54

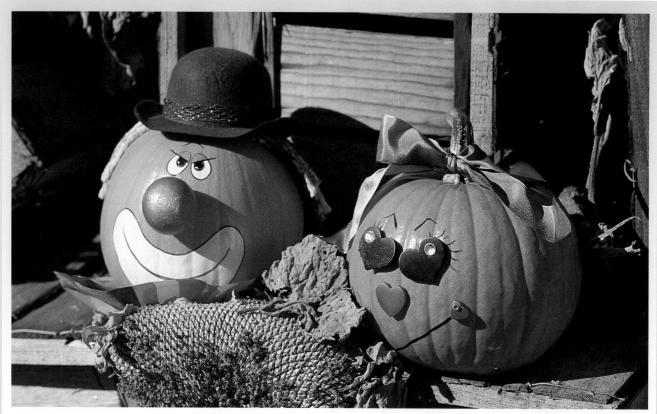

Hearts and Clown II • Vicki Rhodes
Refer to page 56

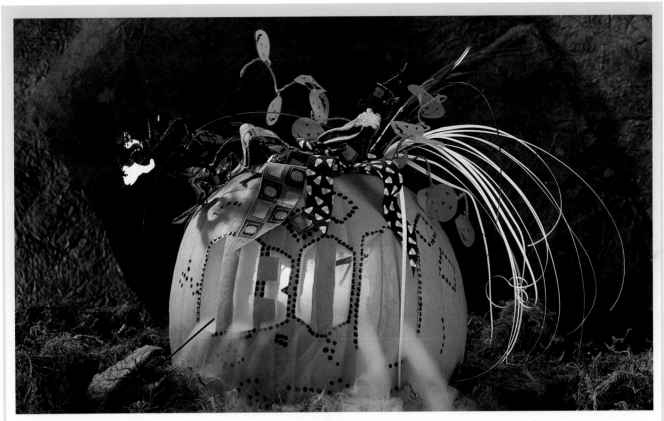

Boo
Refer to page 57

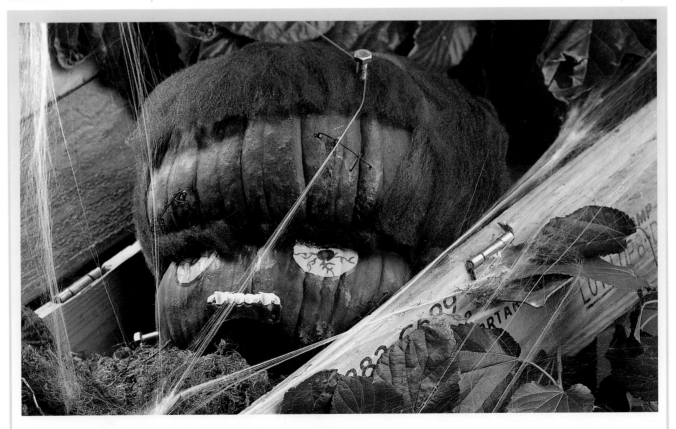

Frank
Refer to page 57

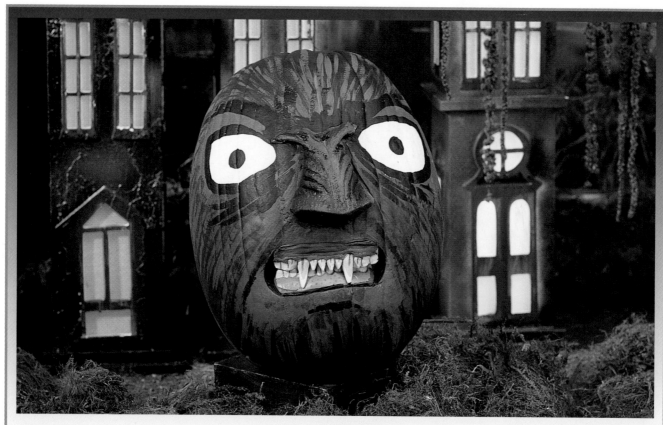

Wolf
Refer to page 58

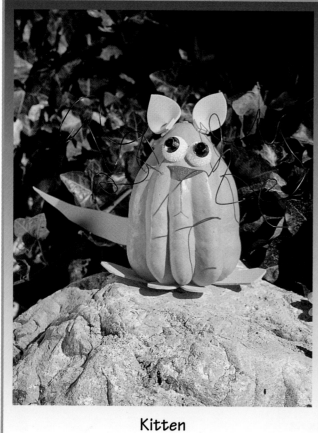

Kitten
Refer to page 58

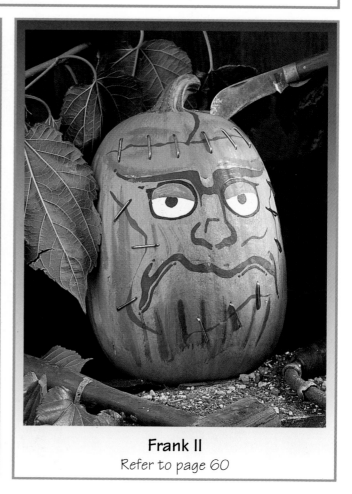

Frank II
Refer to page 60

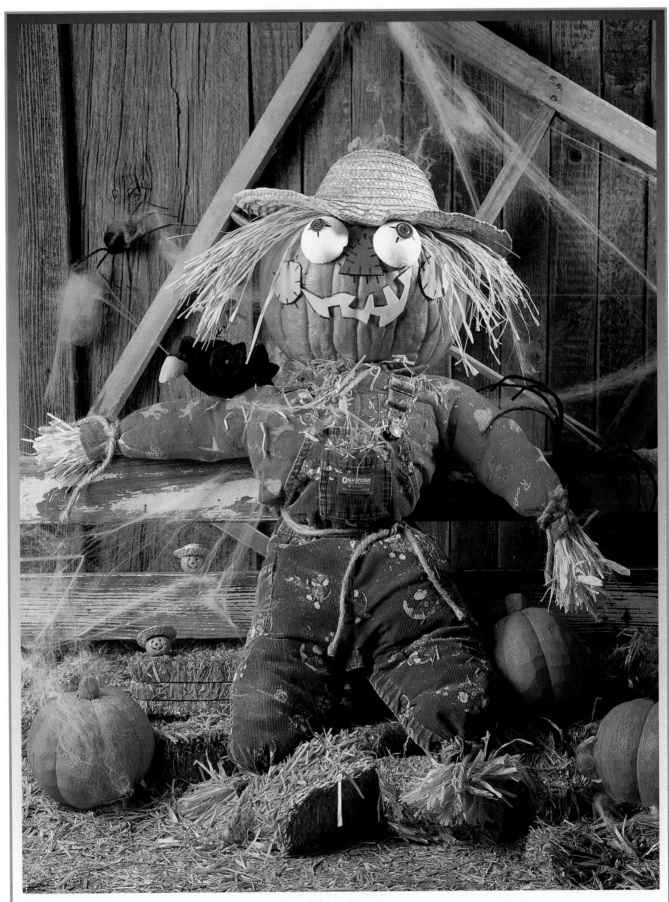

Scarecrow
Refer to page 59

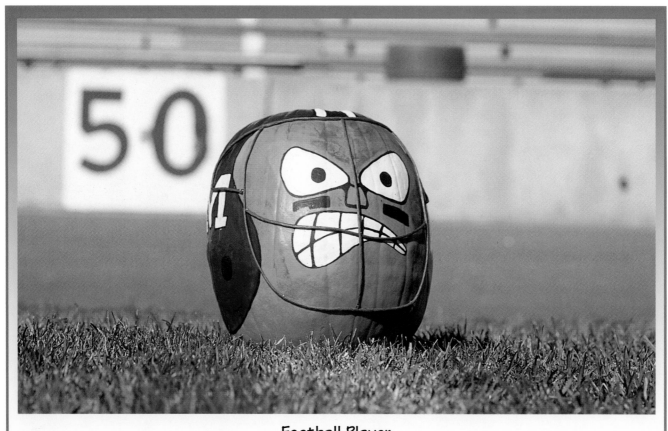

Football Player
Refer to page 60

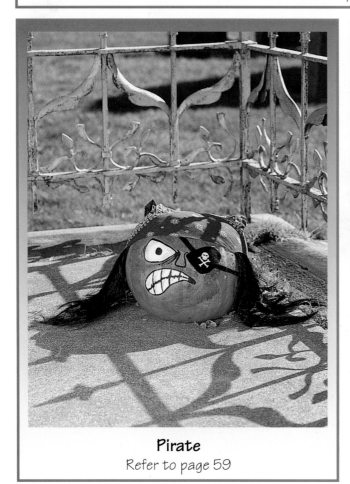

Pirate
Refer to page 59

Snake
Refer to page 61

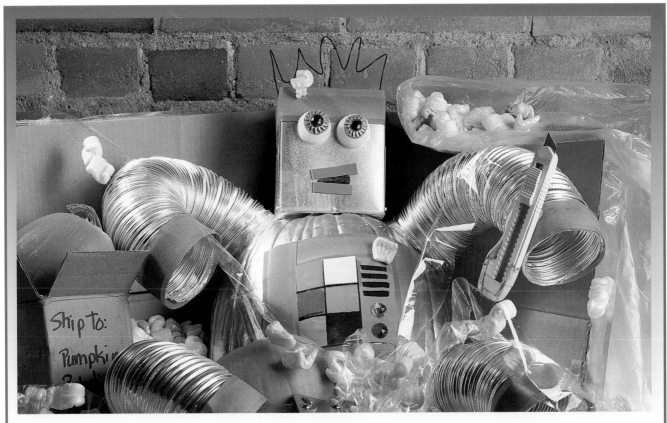

Robot
Refer to page 62

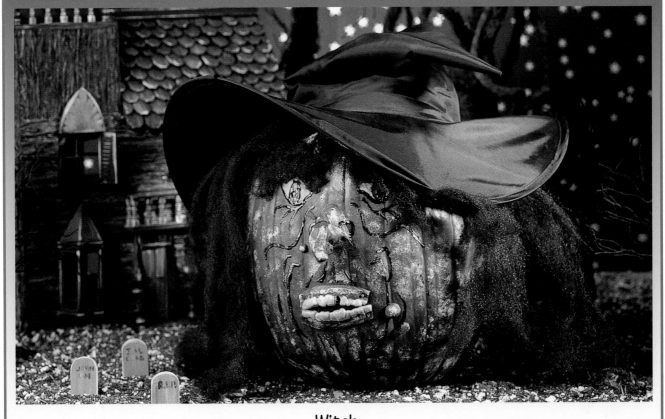

Witch
Refer to page 61

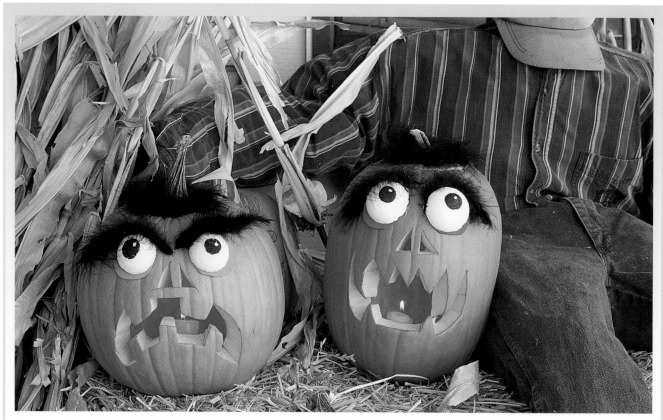

Bert and Ernie
Refer to page 62

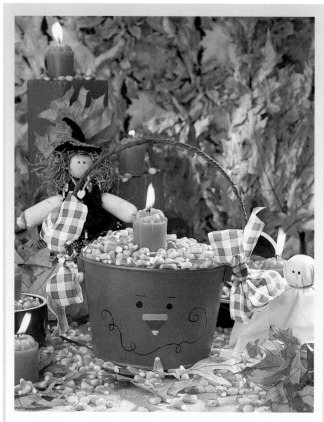

Trick or Treat Bucket
Refer to page 63

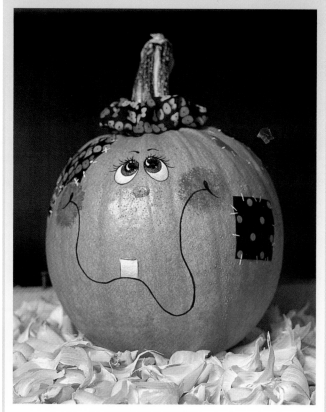

Patches Pumpkin • Vicki Rhodes
Refer to page 63

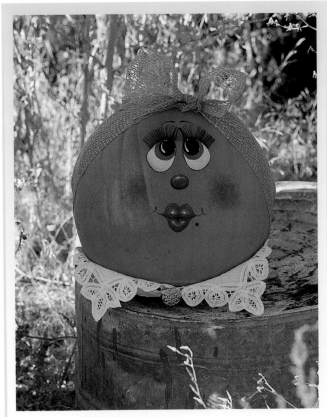

Girlfriend • Vicki Rhodes
Refer to page 64

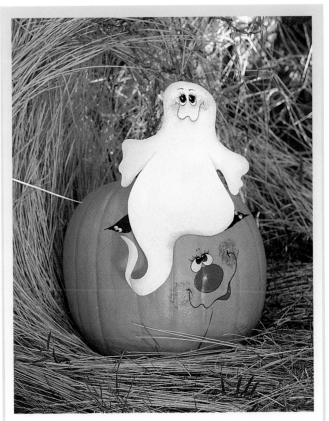

A Ghostly Face • Vicki Rhodes
Refer to page 65

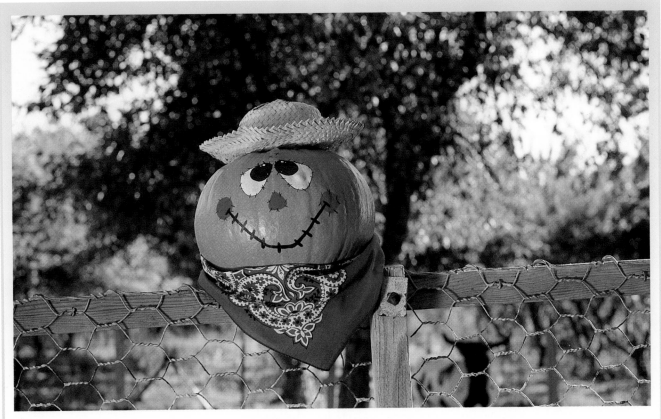

Cowboy • Vicki Rhodes
Refer to page 64

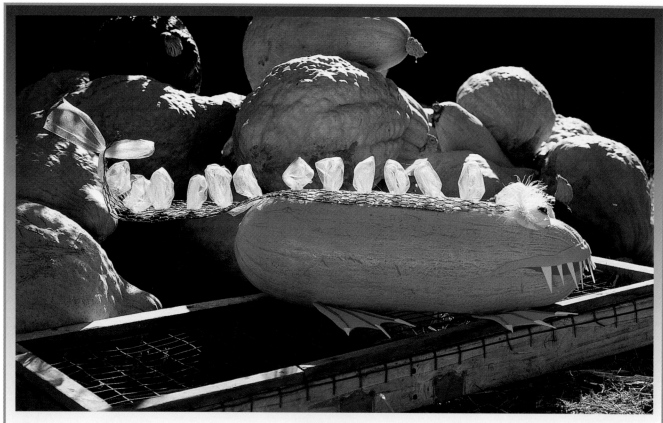

Alligator
Refer to page 66

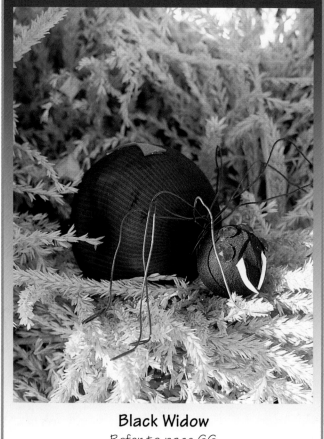

Black Widow
Refer to page 66

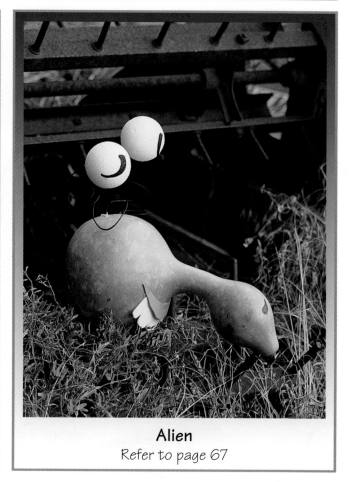

Alien
Refer to page 67

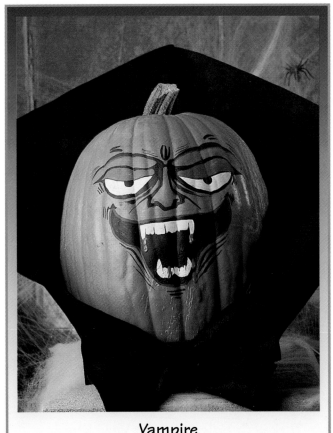

Vampire
Refer to page 67

Welcome • Vicki Rhodes
Refer to page 68

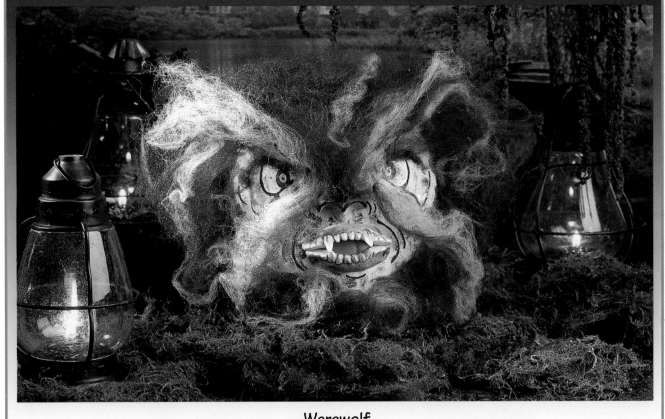

Werewolf
Refer to page 69

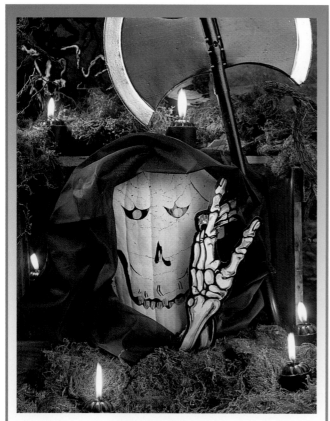

Grim Reaper
Refer to page 69

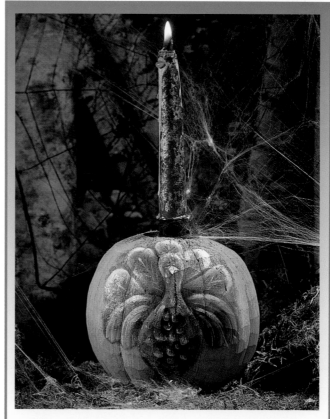

Turkey Candle Holder • Vicki Rhodes
Refer to page 70

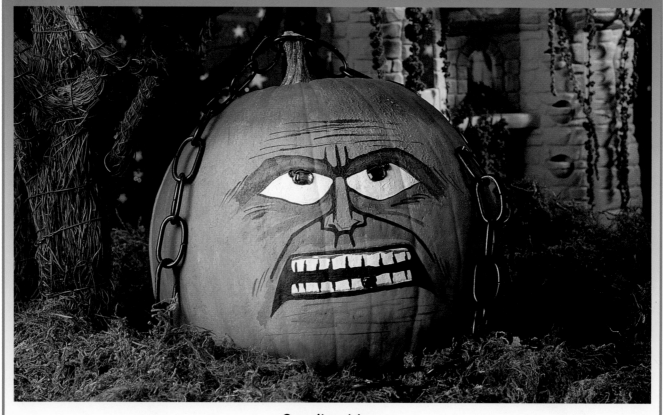

Snarling Man
Refer to page 70

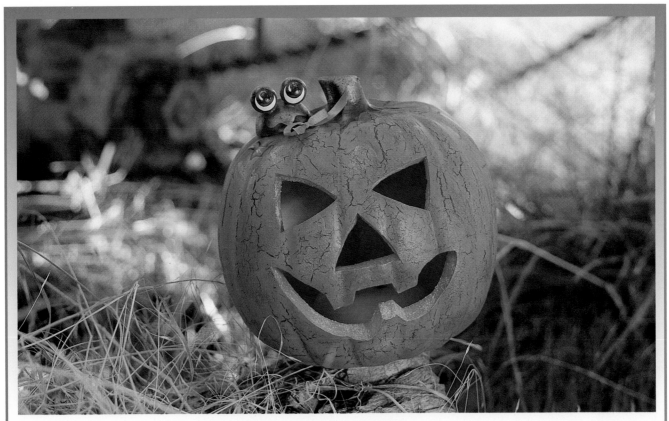

"Toadal" Spell • Vicki Rhodes
Refer to page 71

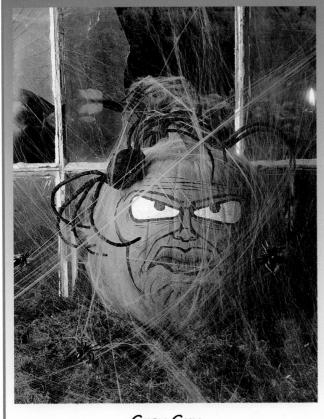

Gray Guy
Refer to page 72

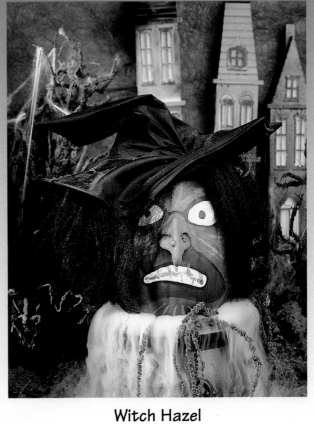

Witch Hazel
Refer to page 72

Oil Pan Pumpkin • Vicki Rhodes
Refer to page 73

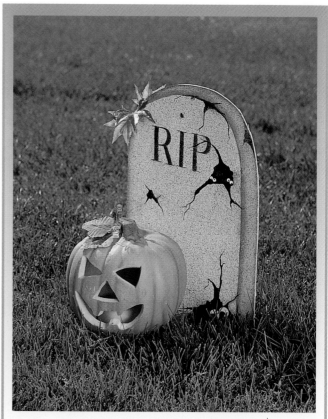

Rest in Peace • Vicki Rhodes
Refer to page 74

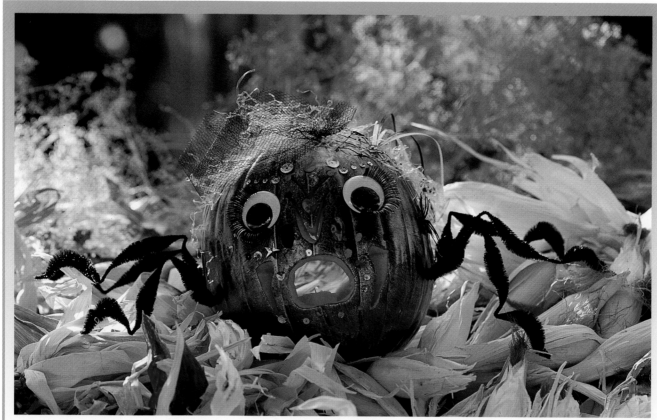

Punk Spider
Refer to page 75

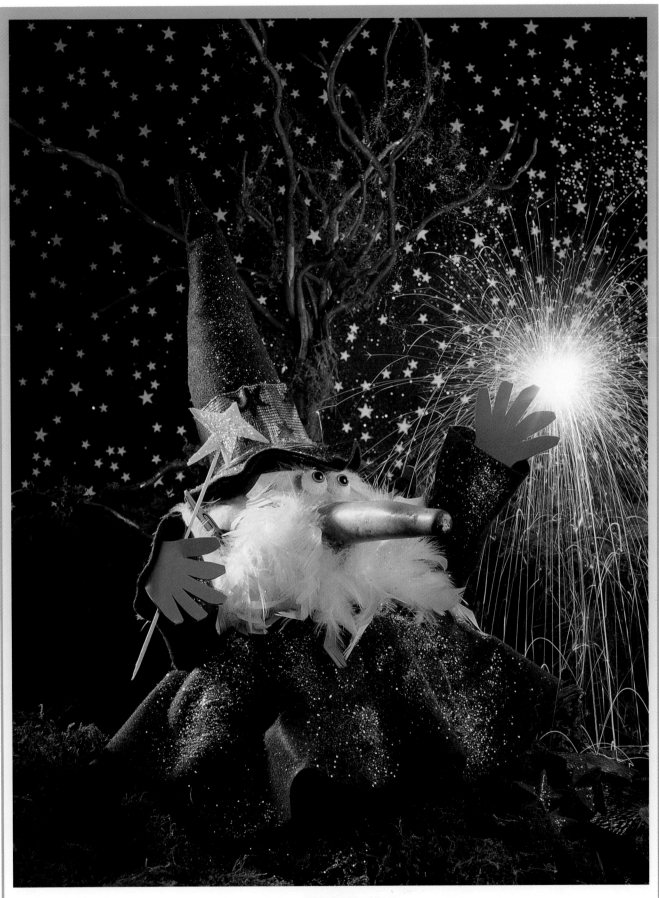

Wizard
Refer to page 76

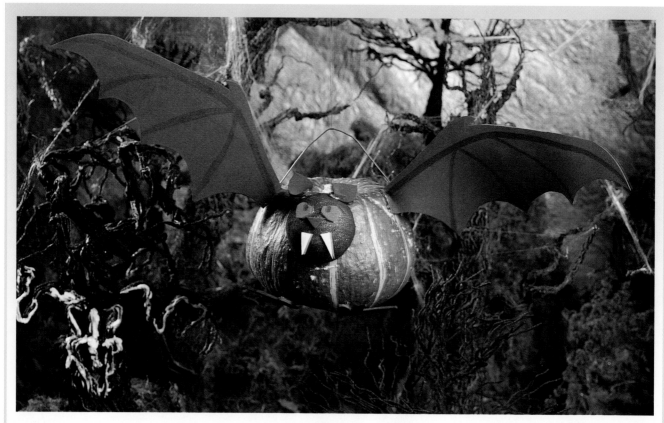

Bats
Refer to page 74

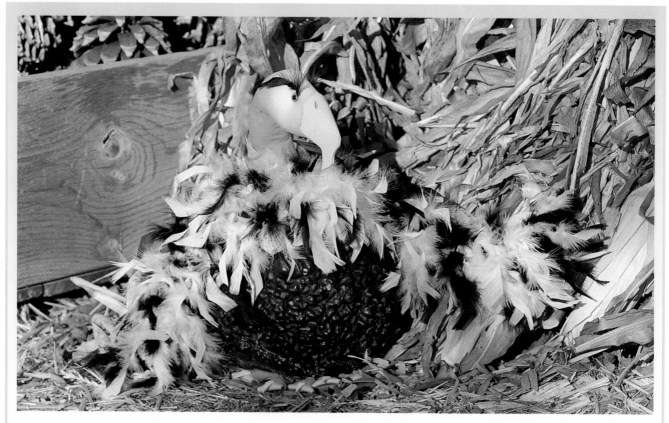

Vulture
Refer to page 77

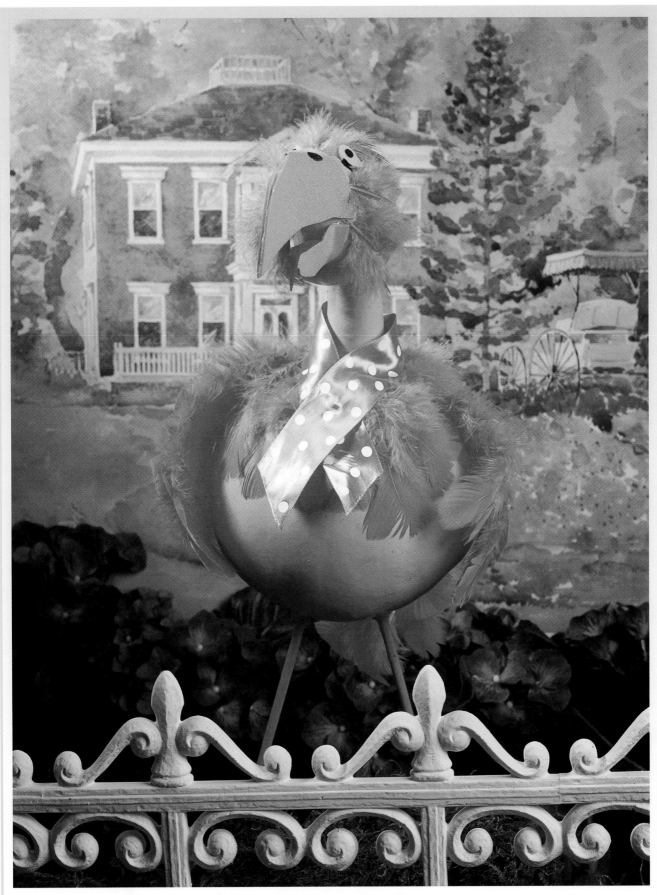

Pink Flamingo
Refer to page 77

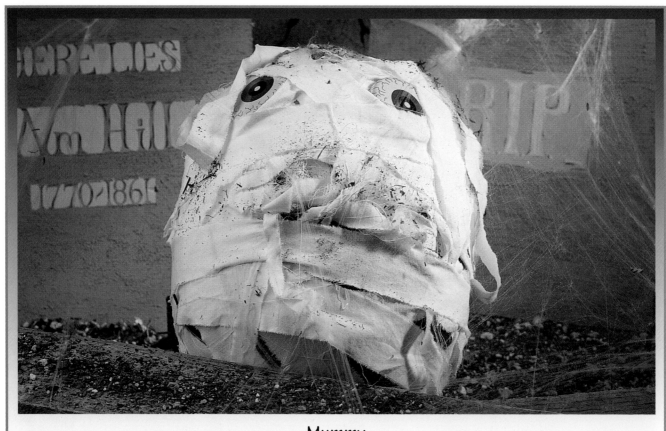

Mummy
Refer to page 78

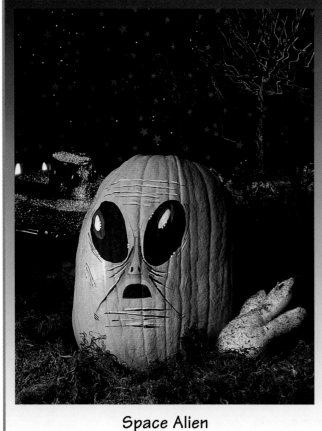

Space Alien
Refer to page 78

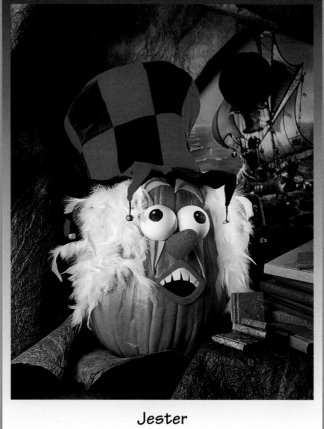

Jester
Refer to page 79

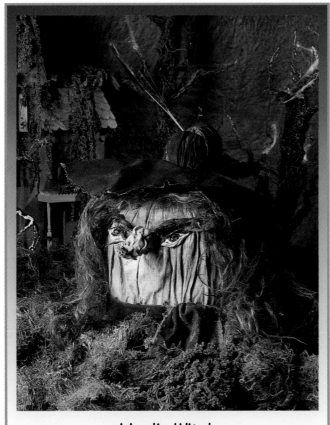

Muslin Witch
Refer to page 80

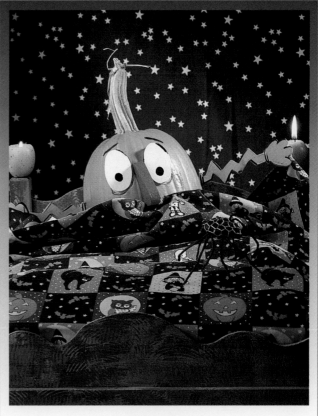

Scared
Refer to page 79

Gourd Jack-O-Lantern • Vicki Rhodes
Refer to page 80

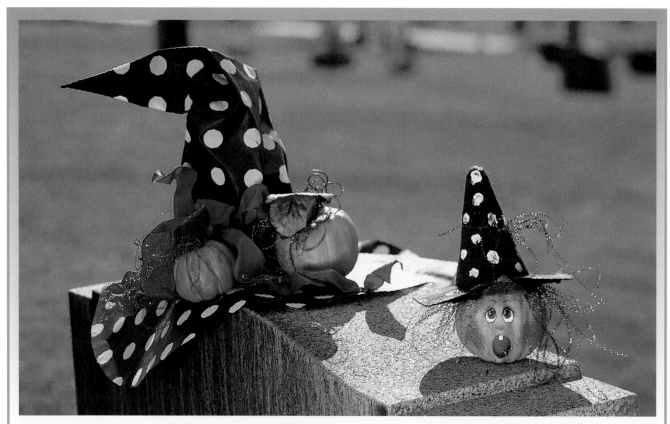

Witches Hat and Small Pumpkins • Vicki Rhodes
Refer to page 81

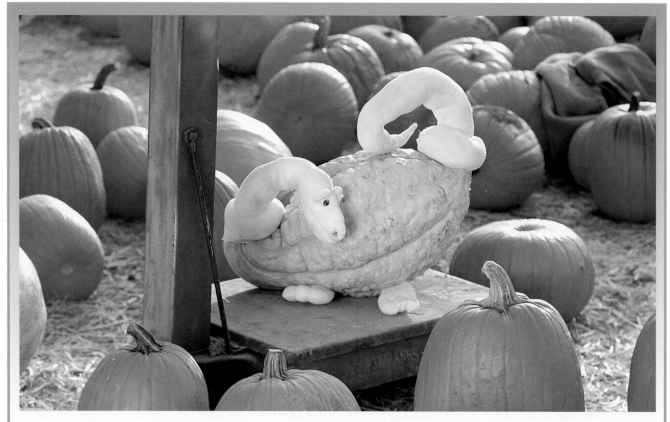

Dragon
Refer to page 82

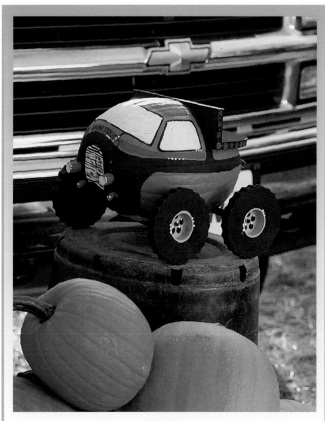

Truck
Refer to page 83

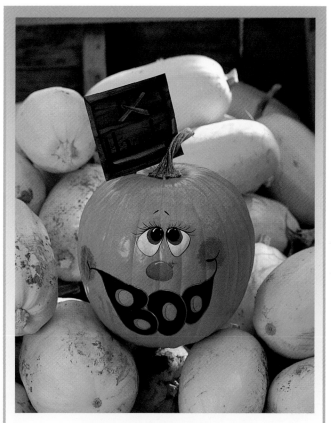

Haunting • Vicki Rhodes
Refer to page 84

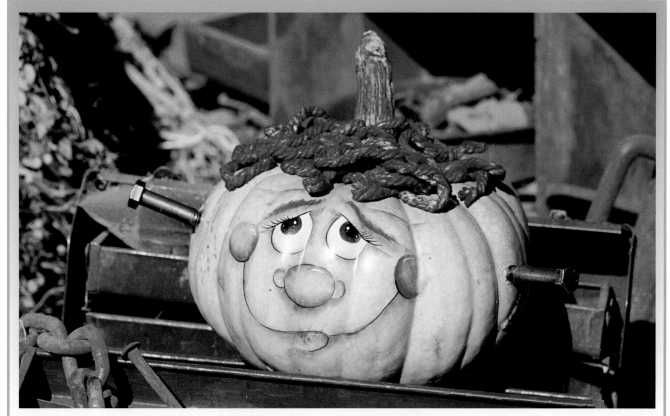

Monster • Vicki Rhodes
Refer to page 85

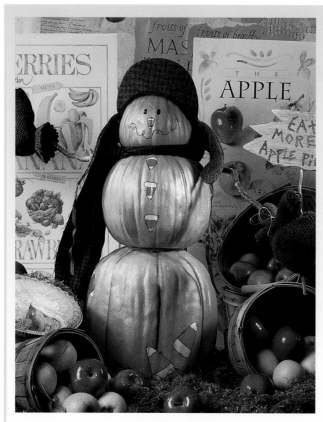

Jack Frost
Refer to page 86

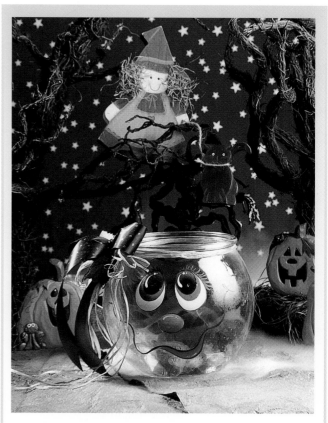

Fishbowl Pumpkin • Vicki Rhodes
Refer to page 86

Fabric Pumpkin • Vicki Rhodes
Refer to page 87

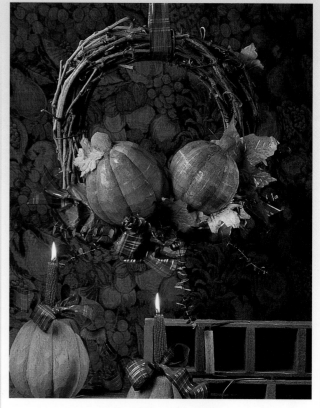

Pumpkin Wreath
Refer to page 87

Golden Pumpkin
Refer to page 88

Gold Leaf Pumpkin • Vicki Rhodes
Refer to page 88

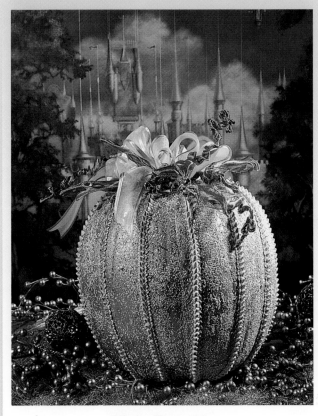

Silver Pumpkin
Refer to page 89

Copper Pumpkin
Refer to page 89

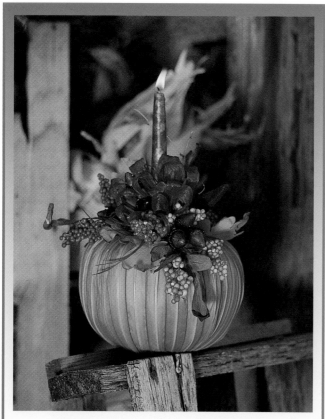

Raffia Pumpkin • Vicki Rhodes
Refer to page 90

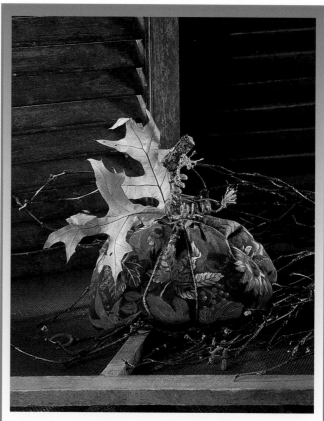

Bean Bag Pumpkin
Refer to page 90

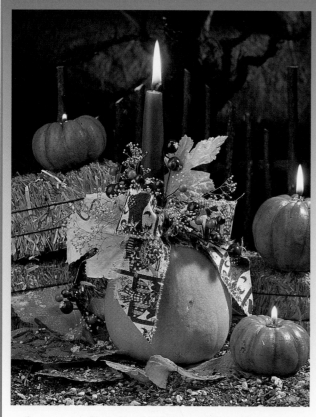

Country Candle Holder • Vicki Rhodes
Refer to page 91

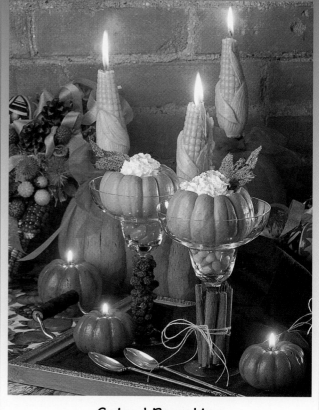

Spiced Pumpkins
Refer to page 91

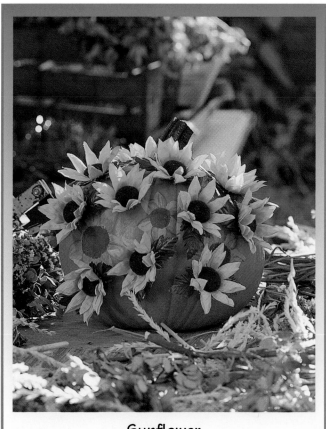

Sunflower
Refer to page 92

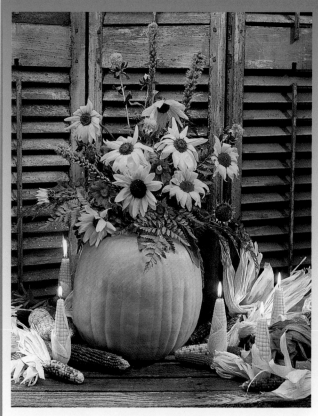

Fresh Flowers in a Pumpkin • Vicki Rhodes
Refer to page 92

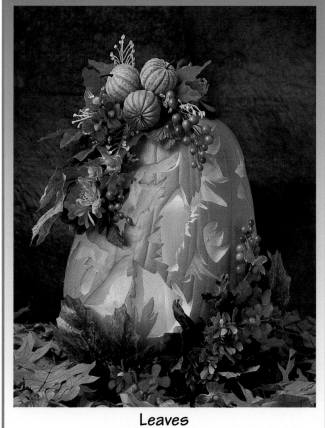

Leaves
Refer to page 93

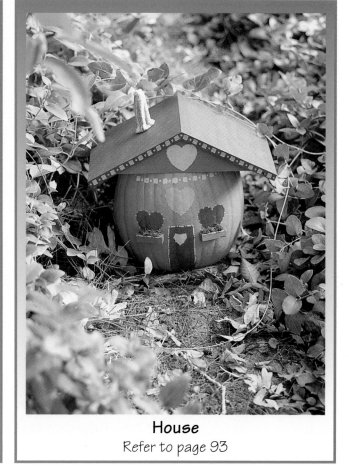

House
Refer to page 93

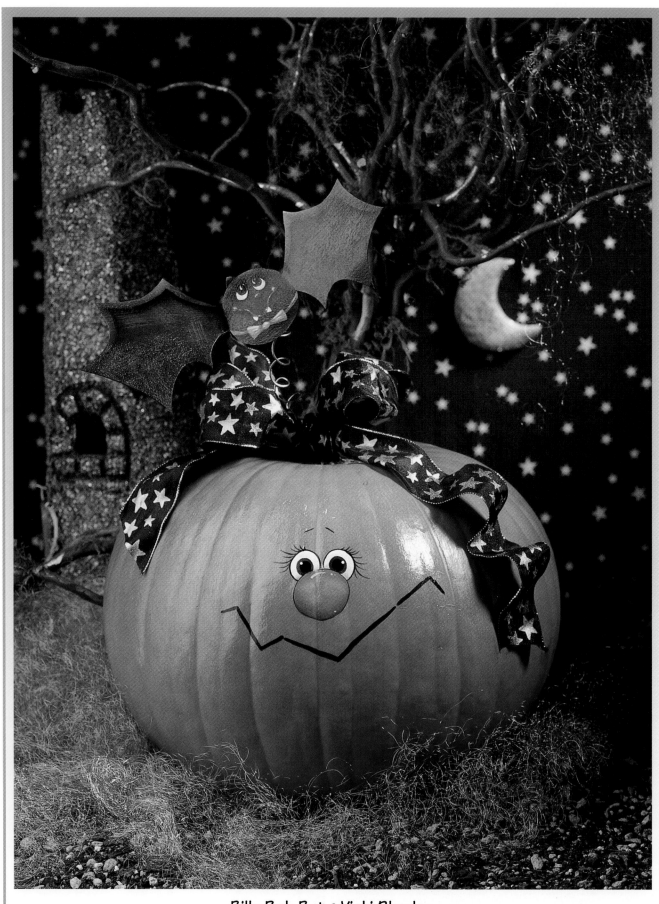

Billy Bob Bat • Vicki Rhodes
Refer to page 94

Pumpkin
Decorating
Patterns
&
Instructions

Bats and Ghosts
Pictured on page 18

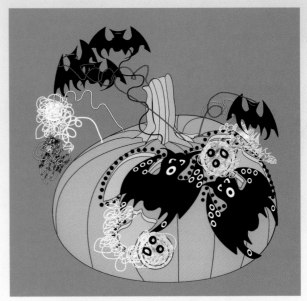

Materials:
Doll hair: white curly. Fabric paint: black.
Floral wire: 12" lengths, black, white (4 each).
Foam sheet: black. Glue gun and glue sticks.
Rhinestones: multi-colored, small.
Styrofoam balls: 1" (3), 2" (1).

Carving:
Carve pumpkin, referring to pattern and
General Instructions.

Decorating:
Cut two large and four small bats from
foam. Hot-glue large bats to front of pump-
kin. Attach small bats to black wires. Twist
and bend wires. Insert into top of pumpkin.
To make ghosts, cut styrofoam balls in half.
Cover round portion of balls with doll hair,
allowing hair to dangle. Hot-glue large
ghosts and one small ghost to pumpkin as
desired. Attach remaining small ghosts to
white wires. Twist and bend wires. Insert into
top of pumpkin. Hot-glue rhinestones to
large bat wings as desired. Hot-glue rhine-
stones to bats and ghosts for eyes and
mouths. Paint dots around carved openings
with fabric paint.

Turkey
Pictured on page 18

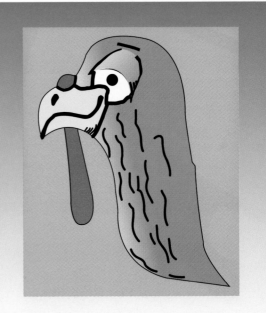

Materials:
Acrylic paints: black, dk. brown, lt. brown,
orange, red, white, yellow. Feathers: assorted
colors. Foam mount board: 5" x 8".
Craft knife. Masking tape. Sandpaper: 80
grit. Straight pins. Tape: masking.

Painting:
Enlarge Turkey head pattern to fit pumpkin.
Cut turkey head from mount board with
exacto knife. Sand edges of head. Paint and
detail head, referring to pattern.

Decorating:
Arrange feathers and attach to back of pumpkin with straight pins and secure with masking tape.
Attach head to front of pumpkin with straight pins.

Bountiful Harvest
Pictured on page 18

Materials:
Straw hat. Pumpkin: 6" wood, prepainted. Vegetables and/or fruit pick. Glue gun and glue sticks. Leaves: silk autumn.

Decorating:
Hot-glue crown of hat to pumpkin. Clip small clusters of leaves from stem. Glue leaves along bottom of pumpkin and back in crown, behind pumpkin. Separate portions of floral pick and glue along bottom of pumpkin. Fill in with more leaves, if needed.

Button Punkin'
Pictured on page 18

Materials:
Fabric: orange wool, 1/3 yd. Buttons, old: dk. colored (12 for mouth), round gold (1 for nose), large round lt. colored (2 for eyes). Dried leaves and vines. Floss: ivory cotton perle (1 ball). Glue gun and glue sticks. Needle. Sewing machine. Stem: 1-1/2"-diameter x 6". Straight pins. Stuffing. Thread: coordinating.

Decorating:
Enlarge Pattern A 200%. Cut six of Pattern A from wool fabric, transferring all markings. Pin two panels right sides together, matching notches. Sew a 1/4" seam along one side of panel. With right sides together, pin and sew a third panel to first two panels. Set aside. Repeat process with remaining three panels. With right sides together, pin and sew panel sets together, beginning and ending 1-1/2" from top. Clip curves and turn right side out. Stuff firmly. Turn top edge in 1/2". Whip-stitch 1-1/2" seams closed. Place stem into opening and hot-glue in place. Cut floss into two 12" lengths. Thread through each eye button and tie into a bow. Hot-glue eyes to pumpkin, referring to photograph for placement. Cut floss into twelve 8" lengths. Cut each length in half. Double-thread through each mouth button and tie into a knot. Hot-glue mouth buttons to pumpkin. Hot-glue round gold nose button to pumpkin. Hot-glue dried leaves and vines around base of stem.

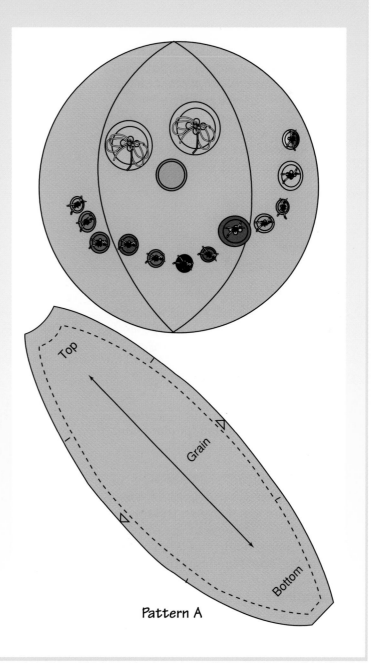

Pattern A

B-O-O!
Pictured on page 19

Materials:
Pumpkins: papier mâché, small (3). Acrylic paints: black, bright blue, dk. orange, lt. orange. Leaves: silk (4). Pencil. Raffia: natural, 2 yds. Straight pins. Wire: light-weight green 2 yds. Wire cutters.

Painting:
Referring to pattern and General Instructions, paint and detail pumpkins as follows: **base** - entire pumpkin dk. orange; **Dry-brush** - with lt. orange: **Detail** - lettering black; **line** - bright blue.

Decorating:
Cut raffia into three equal lengths. Knot ends. Tie into bows around stems of pumpkins. Secure bow to stems with straight pins. Cut wire into three equal lengths. Wrap wires around pencil to form vines. Wrap a wire vine around each pumpkin stem. Attach a leaf or two to base of each pumpkin stem. Secure with straight pins.

Birdhouse
Pictured on page 19

Materials:
Gourd: papier mâché. Acrylic paints: black, green, orange, dk. orange, white. Glue gun and glue sticks. Craft knife. Leaf stem (perch). Raffia: natural, 1 yd.

Carving:
Cut one 2"-diameter circle in gourd, referring to photograph for placement.

Painting:
Referring to pattern and General Instructions, paint and detail gourd as follows: **base** - entire gourd orange; **lettering** - black; **wash** - border and door strips white; check pattern green; **float** (shade) - border strips dk. orange; **spatter** - front of gourd dk. orange.

Decorating:
Hot-glue leaf stem to inside of opening for perch, referring to photograph for placement. Tie raffia into a double-loop bow around stem of gourd. Knot ends. Gently spread raffia open.

Straw Hat
Pictured on page 19

Materials:
Acrylic paints: aqua, black, dk. green, dusty pink, red, dk. red, white. Glue gun and glue sticks. Leaf stem: silk with two leaves. Ribbon: 2"-wide black-and-white polka-dot, 1-1/2 yds. Straw hat: orange. Tree branch: 2".

Painting:
Referring to pattern and General Instructions, paint and detail top of hat as follows: **base** - eyes white; irises dk. green; pupils black; nose and mouth red; **float** (shade) - eyes aqua; nose dk. red; **float** (highlight) - pupils aqua; nose and mouth dusty pink; **stipple** - cheeks dusty pink; **line** - eyebrows, eyelashes, eyes, nose and mouth black; **comma strokes** - eyes, nose and mouth white; **dots** - eyes, nose and mouth white.

Decorating:
Roll up edges of hat brim to form a triangle. Secure with hot glue. Hot-glue leaf stem to top of hat, referring to photograph for placement. Tie ribbon into bow at base of brim for a bow tie.

Leaves on a Pumpkin
Pictured on page 20

Materials:
Acrylic paint: black. Leaves: real sprigs (2), single (5). Pencil. Raffia: natural, 1 yd. Straight pins. Wire: green paper twist, 2 yds. Wire cutters.

Painting:
Paint and detail pumpkin, referring to pattern.

Decorating:
Cut paper twist wire into three 18" lengths. Loosely wrap each wire around pencil to form vines. Twist strands of raffia through vines. Attach vines to base of pumpkin stem with straight pins. Attach single leaves to base of stem with straight pins. Cut paper twist wire into one 15" length.

Loosely wrap wire around pencil to form a vine. Remove 1/2" of paper from each end of wire. Loop raffia into a bow and knot center with remaining wire. Center and attach bow with straight pins 2" from bottom of pumpkin. Thread vine through bow and insert exposed wires into pumpkin. Attach leaf sprigs with straight pins at sides of bow.

Ghost
Pictured on page 20

Materials:
Acrylic paint: black. Fabric: white,
1 yd. Straight pins.

Painting:
Drape fabric over pumpkin. Attach with
straight pins. Referring to pattern paint
eyes and mouth in black.

Cousin It
Pictured on page 20

Materials:
Glue gun and glue sticks. Hat: black felt. Novelty items: nose with glasses, eyebrows and
mustache; long blonde wig.

Decorating:
Remove handles from nose piece. Drape wig over pumpkin and hot-glue in place. Hot-glue hat and
nose piece to wig, referring to photograph for placement.

CLOWN
Pictured on page 21

Materials:
Acrylic paints: black, lt. blue, bright
orange, pink, white. Clown's hat.
Craft glue. Novelty item: clown nose.
Straight pins.

Painting:
Paint and detail pumpkin, referring
to pattern.

Decorating:
Glue nose to pumpkin face. Attach
hat to pumpkin with straight pins.

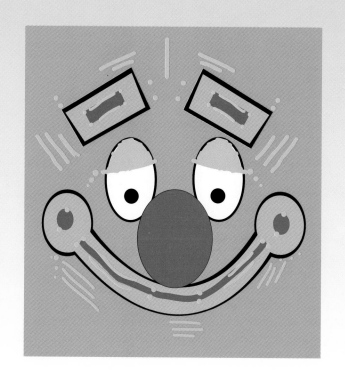

Dressed to Fill
Pictured on page 21

Materials:
Bucket: 7 qt. yellow. Acrylic paints: black, gray, dk. green, lt. green, dusty pink, lt. purple, red, dk. red, white. Fabric: black candy corn print, 1/4 yd. Glue gun and glue sticks. Needle: hand-sewing. Sealer: all-purpose. Thread: black. Tissue paper: (1 sheet).

Painting:
Mix each paint color with all-purpose sealer 2:1 for best adhesion. Referring to pattern and General Instructions, paint and detail tub as follows: **base** - eyes and tooth white; irises dk. green; pupils black; cheeks and nose red; **float** (shade) - eyes and tooth lt. purple; cheeks and nose dk. red; **float** (highlight) - irises lt. green; pupils gray; cheeks and nose dusty pink; **line** - eyebrows, eyelashes, eyes, cheeks, nose, mouth and tooth black; **comma strokes** - eyes, nose and cheeks white; **dots** - eyes, cheeks and nose white.

Decorating:
Cut fabric into one 7" x 11" piece and one 4" x 4-1/2" piece. With right sides together, fold larger piece of fabric in half lengthwise. Sew from each end around to the center, leaving a 2" opening in the center. Turn right side out. Tear tissue paper in half and stuff each end of fabric. Sew opening closed. Equally fold 4-1/2" sides of smaller fabric to center. Wrap and pull around center of larger fabric to form a bow tie. Hot-glue ends together. Hot-glue bow tie to bottom of bucket. Fill as desired.

Silhouette Pumpkin
Pictured on page 21

Materials:
Acrylic paint: black. Candle: 2-1/2" diameter.

Painting:
Paint and detail pumpkin, referring to pattern.

Carving:
Carve hole 1/2" deep into top of pumpkin same diameter as candle. Insert candle.

Bagged Pumpkin
Pictured on page 22

Materials:
Fabric: muslin, 1/2 yd. Acrylic paints: black, dk. green, bright red, white. Jute: 1 yd. Lace: 3/4"-wide, 3/4 yd. Stuffing. Sewing machine. Straight pins. Tea Bags: (2). Textile medium. Thread: coordinating.

Decorating:
Cut muslin fabric into two 11" x 15-1/2" pieces. With right sides together, sew a 1/4" seam along sides and bottom of rectangle to form a bag. Turn right side out. Fold top edges in 1/4" and press. Pin and sew lace around top edges. Place tea bags into a pot of boiling water and allow to steep for a few minutes. Immerse bag in pot until desired color is achieved. Remove bag from pot and lay flat to dry. Transfer pattern onto bag and paint as instructed in Painting below. Fill bag with stuffing. Tie jute around corners. Hand-gather top of bag. Wrap jute around bag, gather and tie into bow.

Painting:
Mix each paint color with textile medium 1:1. **Dry-brush** and detail bag, referring to pattern.

Snider the Spider
Pictured on page 22

Materials:
Pumpkin: compressed styrofoam. Acrylic paints: aqua, black, dk. gray, lt. gray, green, dk. green, magenta, peach, purple, lt. purple, red, dk. red, white. Balls: wooden, 2" (body), 1" (head). Chenille: 12" lengths, white (4). Crackle medium. Craft glue. Glue gun and glue sticks. Ribbon: 1"-wide iridescent burgundy/gray ombré wire-edge, 3/8 yd.

Painting:
Paint pumpkin as in "Toadal" Spell. See page 71. Lightly **dry-brush** chenille legs with black. Hot-glue head to body and **base-coat** with black. Referring to pattern and General Instructions, paint and detail spider as follows: **base** - eyes white; irises green; pupils black; nose and mouth red; spots lt. purple; **float** (shade) - eyes aqua; irises dk. green; nose and mouth dk. red; medium and large spots purple; **float** (highlight) - nose and mouth peach; medium and large spots magenta; **line** - eyebrows, eyelashes and eyes dk. gray; **additional detail lining** - eyebrows and eyelashes lt. gray; **comma strokes** - eyes white; hearts on mouth peach; **dots** - eyes white.

Decorating:
Center and hot-glue legs under body. Bend Chenille ends for feet. Tie ribbon into bow. Hot-glue bow in place. Tack feet to pumpkin where desired.

Hearts
Pictured on page 22

Materials:
Acrylic paints: black, mauve, smoked pearl, dk. red, white. Glue gun and glue sticks. Rhinestones. Ribbon: 2"-wide pastel rainbow wire-edge ombré, 1 yd. Wooden hearts: large (2), small (1), miniature (2).

Painting:
Referring to pattern and General Instructions, paint and detail pumpkin as follows: **base** - large hearts black; small and miniature hearts dk. red; **float** (highlight) - large hearts smoked pearl; small and miniature hearts mauve; **line** - eyebrows, eyelashes and mouth black (after hearts are attached to pumpkin).

Decorating:
Hot-glue rhinestones to large and miniature hearts, referring to pattern for placement. Hot-glue hearts to pumpkin. Tie ribbon into bow around stem of pumpkin.

Clown II
Pictured on page 22

Materials:
Acrylic paints: black, bright green, dk. green, dusty pink, purple, dk. red, pale red, white. Ball: 2"-diameter, wooden (nose). Fabric: 4" x 5" rainbow stripe. Freezer paper. Glaze: glitter. Glue gun and glue sticks. Hat: small black felt. Mop cord: 2 yds. Needle: hand-sewing. Ribbon: 1/2"-wide iridescent purple mesh, 8". Sealer: all-purpose. Thread: coordinating. Varnish: clear.

Painting:
Dry-brush mop cord with bright green. Referring to pattern and General Instructions, paint and detail pumpkin as follows: **base** - nose pale red; eyes and mouth white; irises dk. green; pupils black; eyelids purple; **stipple** - nose dusty pink; **line** - eyebrows, eyes and mouth black; lip dk. red. Mix varnish with glitter glaze and brush nose, mouth and eyelids.

Decorating:
Hot-glue ball to pumpkin for nose. Cut six 12" lengths of mop cord. Tie cords around stem and let hang for hair. Hot-glue ribbon around hat brim. Place hat over stem and hot-glue hat to pumpkin. Lay fabric on freezer paper. Brush all-purpose sealer onto fabric and allow to dry. Run a gather stitch along one long edge of fabric. Gather fabric into a circle to form a ruffled collar. Stitch ends together. Hot-glue collar to bottom of pumpkin.

BOO
Pictured on page 23

Materials:
Fabric paint: black. Glue gun and glue sticks. Novelty items: cats, pumpkins, black streamers, white streamers. Ribbon: 1/2"-wide black candy corn print, 1 yd; 1"-wide green/orange check with pumpkin print, 1 yd.

Carving:
Carve pumpkin, referring to pattern and General Instructions.

Painting:
Outline carving with a dot pattern using fabric paint.

Decorating:
Tie ribbons into bows. Hot-glue bows to top of pumpkin. Drape ribbon tails. Arrange and insert novelty items as desired.

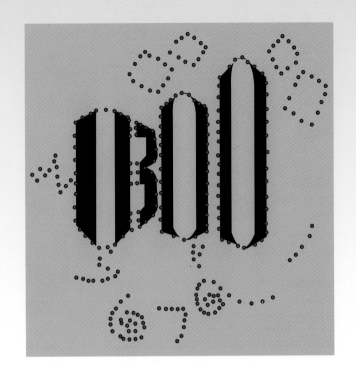

FRANK
Pictured on page 23

Materials:
Acrylic paints: black, bright green, dk. green, red, yellow. Bolts: large (2). Glue gun and glue sticks. Novelty items: blood, hair, black, teeth. Straight pins. Wire,: 12". Wire cutters.

Painting:
Paint pumpkin dk. green. Lightly sponge bright green over dk. green. Paint and detail pumpkin face, referring to pattern. **Dry-brush** dark circles under eyes and enhance chin with black.

Decorating:
Cut a small portion of hair to form two thick, rectangular eyebrows. Hot-glue in place on pumpkin. Style and hot-glue hair to pumpkin, leaving a high brow. Attach teeth with pins. Paint lips to blend with pumpkin face. Cut wire into small lengths and insert into forhead for stitches. Screw bolts into side of pumpkin. Dab blood around stitches and bolts.

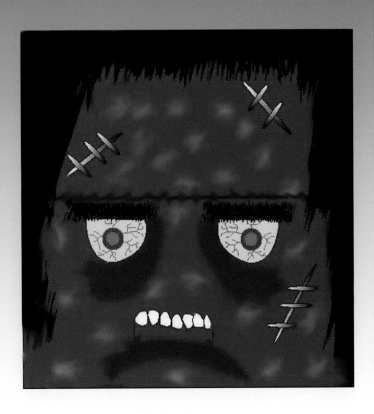

Wolf
Pictured on page 24

Materials:
Acrylic paints: black, brown, lt. brown, gray, white. Novelty items: fangs, nose. Straight pins.

Carving:
Carve a mouth large enough to fit fangs.

Painting:
Paint pumpkin brown. Paint and detail pumpkin face, referring to pattern. Use **dry-brush** technique when painting fur and black facial features.

Decorating:
Attach nose and fangs to pumpkin with straight pins.

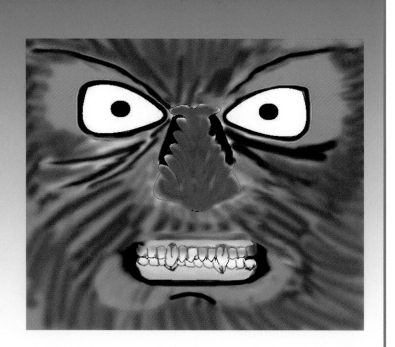

Kitten
Pictured on page 24

Materials:
Acorn squash. Foam sheets: orange, red. Glue gun and glue sticks. Craft glue. Pen: permanent, fine tip black. Rhinestones: round blue (2). Sequins: black (2). Spoon. Styrofoam ball: 1". Wire: lightweight black, 2 yds. Wire cutters.

Decorating:
Remove stem and turn squash upside down. Cut styrofoam ball in half and glue to squash for eyes, referring to photograph for placement. Gently flatten front of eyes with spoon. Hot-glue one rhinestone to each eye. Hot-glue one sequin to center of each rhinestone for pupils. Cut two ears from orange foam sheet. Overlap and hot-glue bottom of each ear to slightly cup. Hot-glue ears in place. Cut wire into six 12" lengths. Randomly twist wires for whiskers and insert three on each side of squash. Cut a small triangle from red foam sheet and hot-glue to center of squash for a nose. Draw mouth with pen. Cut two front feet, two back feet and one tail from orange foam sheet. Hot-glue feet and tail to bottom of squash.

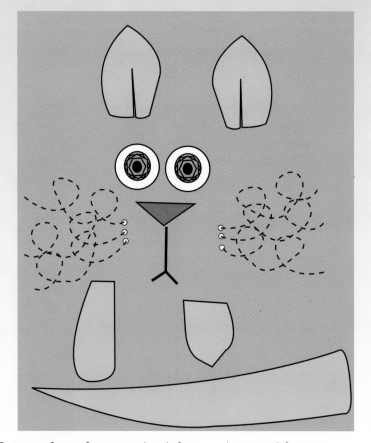

Pirate
Pictured on page 26

Materials:
Acrylic paints: black, white.
Bandana. Felt: 8" x 10" black.
Glue gun and glue sticks.
Straight pins. Witch's wig.

Painting:
Remove stem from pumpkin.
Paint and detail pumpkin, refer-
ring to pattern.

Decorating:
Cut eye patch and patch straps
from felt. Paint skull and cross-
bones on eye patch. Hot-glue
over left eye. Attach wig to
pumpkin with straight pins.
Attach bandana to pumpkin with
straight pins.

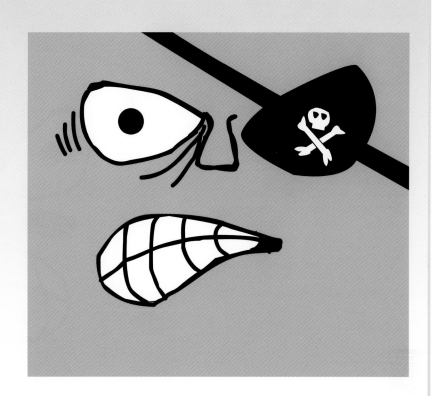

Scarecrow
Pictured on page 25

Materials:
Buttons: 1" blue (2). Foam sheets:
orange, red, yellow. Newspaper.
Permanent marker: black. Raffia:
natural: Rope, 1-1/2 yds. Rubber
bands. Straight pins. Straw
hat. Styrofoam ball: 2". Toddler
clothes: overalls and shirt. Twist ties.

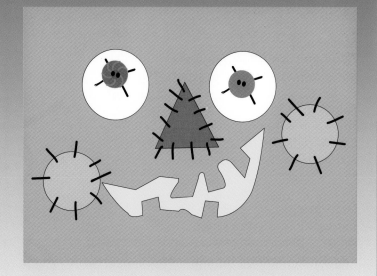

Decorating:
Cut styrofoam ball in half for eyes. Hot
-glue buttons to eyes for pupils. Hot-
glue eyes to pumpkin. Cut a triangle from
red foam sheet for nose and hot-glue in
place. Cut mouth from yellow foam sheet.
Hot-glue mouth to pumpkin. Cut two
circles from orange foam sheet for cheeks
and hot-glue in place. Outline nose, mouth and cheeks with stitch marks using black marker. Cut
an 18" length of raffia. Tie raffia in center with twist ties. Hot-glue raffia on top of pumpkin for hair.
Attach straw hat to top of pumpkin with pins. Button shirt and loosely stuff with newspaper. Pull
overalls over shirt and stuff until body is firm. Cut four 6" lengths of raffia. Fold raffia lengths in
half and secure folds with rubber bands. Insert a raffia bundle into arms and legs. Cut rope into
four 5" lengths. Tie and knot rope around shirt and pant cuffs to hold raffia in place. Tie remaining
rope around waist for belt. Attach body to pumpkin with pins.

Football Player
Pictured on page 26

Materials:
Acrylic paints: black, white, and three complimentary colors of choice for the helmet. Straight pins. Wire: green paper twist, 2 yds. Wire cutters.

Painting:
Remove stem from pumpkin. Paint and detail pumpkin, referring to pattern.

Decorating:
Cut paper twist wire to appropriate lengths to shape and form face mask. Attach wires to pumpkin with straight pins.

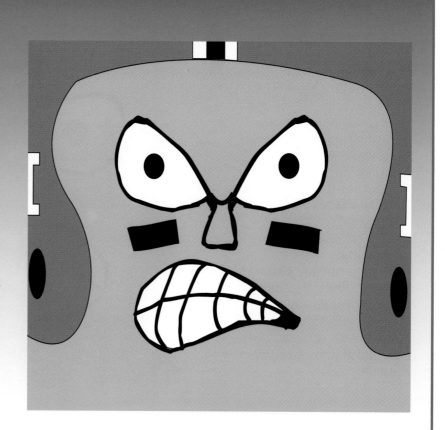

Frank II
Pictured on page 24

Materials:
Acrylic paints: black, gray, red, white. Wire: 1 yd. Wire cutters.

Painting:
Paint and detail pumpkin, referring to pattern. Apply a wash of watered-down gray with downward strokes.

Decorating:
Cut wire into sixteen short lengths. Bend ends of wires and insert into pumpkin for stitches, referring to pattern for placement.

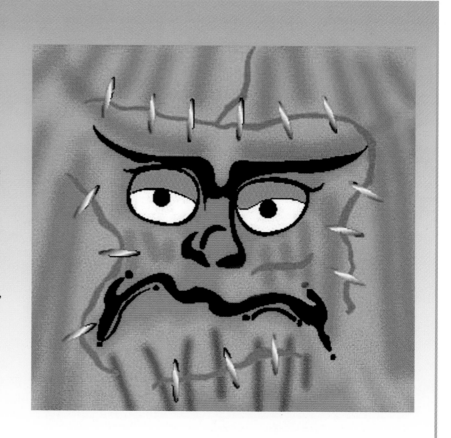

Snake
Pictured on page 26

Materials:
Beads: black iridescent cluster (2). Foam sheets: green, red. Glue gun and glue sticks. Needle: hand-sewing. Nylon stockings: queen-sized navy. Stuffing. Thread: coordinating. Wire: 1 yd. Wire cutters.

Decorating:
Cut legs of stockings off at top of thighs and cut out toes. Turn one leg inside out. Sew end into a tapered tail. Trim excess. Turn right side out and loosely stuff. Turn pumpkin sideways and insert it 6" into other stocking leg. Loosely stuff stocking behindpumpkin. Firmly stuff

stocking in front of pumpkin for head. Measure wire from pumpkin to end of tail and cut. Insert wire into pumpkin and down through tail. Overlap ends of stockings and sew together. To form mouth on head of stocking, turn opening in 1/2" and tack it shut. Thread needle, knot and push needle through head. Pull tightly and secure thread to form indentations for eyes. Repeat process for nostrils. Hot-glue beads in indentations for eyes. Cut a tongue from red foam sheet. Cut various-sized spirals from green foam sheet and randomly glue to snake. Bend tail wire to coil.

Witch
Pictured on page 27

Materials:
Acrylic paints: bright green, dk. green, red, yellow. Fabric paint: black. Glue gun and glue sticks. Novelty items: latex skin; teeth; wig, black. Sponge. Straight pins. Witch's hat.

Painting:
Form latex skin into a long nose and several warts. Press in place on pumpkin. Paint nose, warts and pumpkin dk. green. Paint and detail pumpkin face, referring to pattern. **Sponge** face with bright green.

Decorating:
Hot-glue wig to top of pumpkin. Cut a small portion of hair from wig and hot-glue for eyebrows and to stick out of warts. Attach teeth with straight pins. Paint lips to blend with pumpkin face. Shape hat as desired with straight pins to pumpkin.

Robot
Pictured on page 27

Materials:
Buttons: 1" sun-shaped (2). Dryer venting: flexible aluminum, 2-1/2 yds. Facial tissue box: boutique-size. Foam sheets: green, red, white. Glue gun and glue sticks. Knife: serrated. Pen: black felt marker. Reflective ribbon tape: 1-1/2 yds. Rhinestones: large, round red and yellow. Spray paint: silver. Straight pins. Styrofoam ball: 1-1/2". Wire: bailing, 1 yd. Wire cutters.

Decorating:
Spray paint tissue box and pumpkin. Let dry thoroughly. Place open end of tissue box over stem and hot-glue onto pumpkin for head. Attach reflective ribbon tape around top of tissue box. Cut styrofoam ball in half for eyes. Hot-glue eyes on head, referring to photograph for placement. Hot-glue buttons onto eyes for pupils. Coil wire and hot-glue ends to sides of head for antenna. Draw a rectangle with black felt marker for mouth. Cut two narrow rectangles from green foam sheet for lips and hot-glue in place. Cut dryer venting into four equal lengths with serrated knife. Hot-glue and pin venting pieces to pumpkin for arms and legs. Attach reflective ribbon tape around ends of each venting piece. Cut green foam sheet into one 6" square. Draw lines for control panel with black felt marker. Cut one 2" square from red foam sheet and white foam sheet and hot-glue to control panel. Hot-glue rhinestones to control panel.

Bert & Ernie
Pictured on page 28

Materials:
Acrylic paints: black, white. Feathers: black. Foam sheets: green, red. Glue gun and glue sticks. Styrofoam balls: 2" (2).

Carving:
Refer to patterns and General Instructions.

Decorating:
Cut two 2"-diameter circles from green foam sheet and two from red foam sheet. Cut styrofoam balls in half for eyes. Paint a black circle in center of each eye. Add a dot of white paint to each black circle. Referring to photograph for placement, hot-glue a pair of eyes to green foam circles and a pair to red foam circles, slightly off center. Hot-glue eyes to pumpkins. Hot-glue feathers above eyes for eyebrows and around stems for hair.

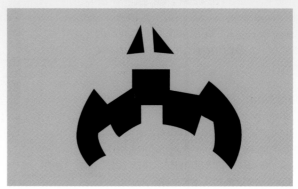

Trick or Treat Bucket
Pictured on page 28

Materials:
Bucket: 7"-diameter, metal. Acrylic paints: black, purple, bright red, dk. red, white, lt. yellow, dk. yellow. Ribbon: 1 -1/2"-wide wire-edge purple, 1-1/4 yds.; purple-check, 1-1/4 yds. Texture paste.

Painting:
Mix bright red and lt. yellow 1:1 for basecoat. Mix basecoat with texture paste 1:1 and paint outside of bucket. Let dry thoroughly. Paint lip of bucket purple. Paint face on bucket, referring to pattern. Let dry thoroughly.

Decorating:
Tightly wrap purple ribbon around handle of bucket. Cut purple-check ribbon into two equal lengths. Referring to photograph, tie each ribbon into a bow around end of handle.

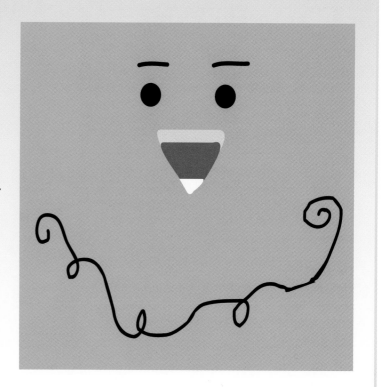

Patches Pumpkin
Pictured on page 28

Materials:
Acrylic paints: black, green, lt. purple, red, dk. red, white. Fabric: 3" x 8" Halloween print; scraps (3). Freezer paper. Glue gun and glue sticks. Sealer: all-purpose. Wire: lightweight, 6".

Painting:
Referring to pattern and General Instructions, paint and detail pumpkin as follows: **base** - eyes and tooth white; irises green; pupils black; nose red; **float** (shade) - eyes and tooth lt. purple; nose dk. red; **float** (highlight) - nose white; **stipple** - cheeks red; **line** - eyebrows, eyelashes, eyes, mouth and tooth black; stitches white; **comma strokes** - eyes and nose white; **dots** - eyes and nose white.

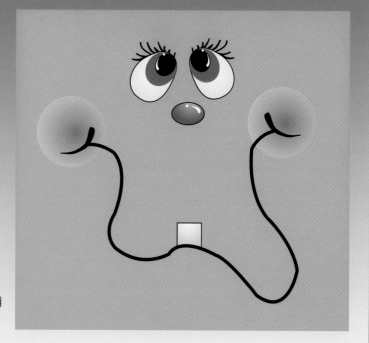

Decorating:
Cut fabric scraps into patches. Lay patches on freezer paper. Brush all-purpose sealer onto patches and allow to dry. Hot-glue patches onto pumpkin, referring to photograph for placement. With right sides together, fold Halloween fabric in half lengthwise and sew into a tube with a gather stitch. Turn right side out. Insert wire into tube. Bend into circle. Gather fabric to form a scrunchie and place around stem.

Cowboy
Pictured on page 29

Materials:
Acrylic paints: black, brown, red, white.
Bandanna. Glue gun and glue sticks.
Straw hat.

Painting:
Referring to pattern and General
Instructions, paint and detail pumpkin
as follows: **base** - eyes white; irises
brown; pupils black; cheeks and nose red;
line - eyes, mouth and stitches black;
dots - eyes white.

Decorating:
Hot-glue hat to pumpkin. Tie bandanna
around base of pumpkin, referring to
photograph. Secure to pumpkin with
hot glue.

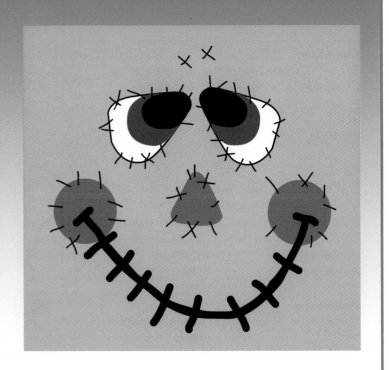

Girlfriend
Pictured on page 29

Materials:
Acrylic paints: black, dusty blue, mauve,
lt. purple, red, dk. red, white. Button: 1"
gold. Doily: 5" square Battenburg,
white. Glue gun and glue sticks.
Novelty item: eyelashes. Ribbon:
1/2"-wide gold metallic mesh, 1 yd.

Painting:
Referring to pattern and General
Instructions, paint and detail
pumpkin as follows: **base** - eyes
white; irises dusty blue; pupils and
mole black; nose and mouth red;
float (shade) - eyes lt. purple; nose
and mouth dk. red; **float** (highlight)
- nose and mouth mauve; additional
highlights in mouth white; **stipple** -
cheeks red; **line** - eyebrows and eyes
black; nose and mouth dk. red; **comma strokes** - eyes white dots - eyes white.

Decorating:
Cut doily in half. Hot-glue to bottom of pumpkin for collar. Hot-glue button to center of collar for a
brooch. Hot-glue eyelashes to top of eyes. Wrap ribbon around pumpkin for head band and tie into
bow at top. Tuck ribbon tails under band.

A Ghostly Face
Pictured on page 29

Materials:
Acrylic paints: black, brown, gray, dk. gray, dk. green, dusty pink, dk. red, white. Glue gun and glue sticks. Novelty eyes: small (4). Varnish: gloss. Watercolor paper: 11" x 16", 400 lb. cold-pressed, white.

Painting Ghost:
Cut ghost from watercolor paper. Referring to pattern and General Instructions, paint and detail ghost on smooth side of paper as follows: **base** - eyes white; irises dk. green; pupils black; **float** (shade) - eyes, mouth and outer edge of ghost gray; **float** (highlight) - outer edge of ghost dusty pink; **stipple** - cheeks dusty pink; **line** - eyebrows, eye lashes, eyes and mouth black; **comma stroke** - eyes white; **dots** - eyes white; **spatter** - entire ghost dk. gray. Apply a coat of varnish to both sides of paper. Bend and shape paper while still damp. Let dry thoroughly. Apply a second coat of varnish and further bend and shape paper as desired.

Paint and detail pumpkin as follows:
Base - eyes white; irises brown; pupils and cracks black; mouth and nose dk. red; **float** (shade) - nose dusty pink; **stipple** - cheeks dusty pink; **line** - eyelashes, eyes, nose and mouth black; **dots** - eyes and nose white.

Decorating:
Hot-glue ghost and pairs of novelty eyes to pumpkin, referring to photograph and diagram for placement.

Alligator
Pictured on page 30

Materials:
Banana squash. Feathers: peach (2). Foam sheets: green, red, white. Glue gun and glue sticks. Pen: black marker. Rhinestones: round purple (2). Ribbon: foam-covered chicken wire. Sequins: black (2). Styrofoam ball: 2". Tule: 3"-wide peach, 2 yds.

Decorating:
Cut styrofoam ball in half for eyes. Cut two asterisk shapes from green foam sheet. Hot-glue a rhinestone to center of each asterisk. Hot-glue a sequin to center of each rhinestone for pupil. Hot-glue asterisks onto center of eyes.
Cut a long, narrow mouth from red foam sheet. Cut an upper lip from orange foam sheet with same curve as mouth. Cut 15 narrow triangles in a variety of lengths from white foam sheet to create teeth. Hot-glue teeth to mouth. Overlap lip on teeth and hot-glue in place. Referring to photograph, hot-glue mouth and eyes to squash. Hot-glue a feather above each eye for eyebrows. Draw nostrils above mouth with black marker. Measure ribbon the length of the squash and add 12". Pull tule through chicken wire ribbon at three-hole increments to make spines. Hot-glue ribbon from top of eyes down center back of squash, leaving a 12" tail. Cut two front feet and two back feet from orange foam sheet. Cut three strips of green foam for each foot and hot-glue to each foot. Hot-glue feet to bottom of squash.

Black Widow
Pictured on page 30

Materials:
Foam sheets: red, white. Glue gun and glue sticks. Nylon knee-high stocking: black (1). Rhinestones: round red (4). Spray paint: black. Styrofoam ball: 2". Wire: black, 2-2/3 yds. Wire cutters.

Painting:
Spray paint styrofoam ball black.

Decorating:
Insert styrofoam ball into toe of stocking. Insert small pumpkin behind styrofoam ball. Gather and sew stocking closed around back of pumpkin. Cut off excess stocking. Cut wire into four 24" lengths. Bend ends of wires to form feet. Center and twist each wire around neck of spider (area between ball and pumpkin) for legs. Cut hourglass shape from red foam sheet. Center and hot-glue to back of spider. Cut two fangs from white foam. Referring to photograph for placement, hot-glue fangs and rhinestones to head of spider.

Alien
Pictured on page 30

Materials:
Birdhouse gourd. Foam sheets: green, white. Glue gun and glue sticks. Pen: black marker. Styrofoam balls: 2" (2). Wire: 12" (2).

Decorating:
Spiral each wire. Attach styrofoam ball to one end of each wire for eyes. Insert opposite end of wires into back of gourd. Color pupils onto eyes with black marker. Cut upper lip from green foam sheet. Cut teeth from white foam sheet. Referring to photograph for placement, hot-glue teeth to gourd. Slightly overlap lip onto teeth and hot-glue in place. Color mouth opening and nostrils with black marker.

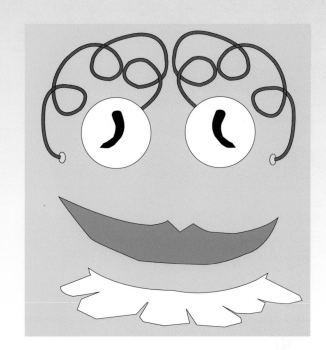

Vampire
Pictured on page 31

Materials:
Acrylic paints: black, black-green, red, white. Black felt squares (5). Glue gun and glue sticks. Stapler and staples.

Painting:
Paint and detail pumpkin, referring to pattern.

Decorating:
Sew two felt squares right sides together to create a Vampire's collar. Sew a large dart along seam. Fold open and sew along edges of dart to form back collar. Cut felt square into one 7" x 9" piece and one 2" x 4" piece. Pleat large piece like a bow tie. Fold small piece in half lengthwise and wrap around center of bow tie. Staple in back. Staple two corners of remaining two felt squares together for front collar. Center stapled corners at bottom front of pumpkin. Wrap collar around sides of pumpkin, stapling to secure. Center back collar at back of pumpkin and wrap collar around sides, stapling to secure. Hot-glue bow tie to front of pumpkin.

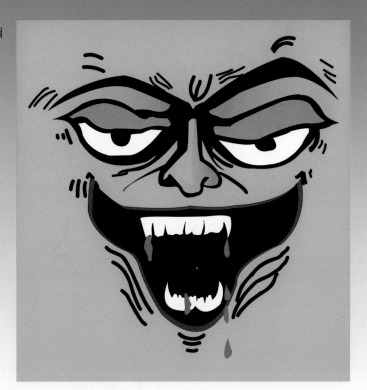

Welcome
Pictured on page 31

Materials:
Pumpkin: large compressed styrofoam. Acrylic paints: aqua, black, green, bright green, magenta, lt. purple, lt. yellow. Glaze: glitter. Glue gun and glue sticks. Pencil. Ribbon: 1-1/2"-wide pastel plaid 1-1/2 yds. Stars: wooden with two holes - large (1), medium (3), small (3); miniature, no holes (2). Varnish: clear. Wire: 16 gauge, 4 ft. Wire cutters.

Painting:
Paint pumpkin stem green. **Dry-brush** stem with bright green to lt. yellow. Paint leaves and tendrils with green. Paint stars designated for "W" and "C" magenta. Paint "E" stars aqua. Paint "O" star green. Paint "L" and "M" stars lt. purple. Let dry. Paint miniature stars and lettering black. **Dot** miniature stars with white for eyes. Mix varnish with glitter glaze and brush onto stars as desired.

Decorating:
Beginning with "W" and leaving a 6" length, weave wire down through first hole, behind star, and up through second hole. Curl wire around pencil as desired and repeat process for "E" star. Continue process until all stars are attached, leaving a 6" length at end. Insert ends of wire into pumpkin and bend inside to secure. Hot-glue stars into eyes of pumpkin. Secure stars to top of pumpkin as needed.

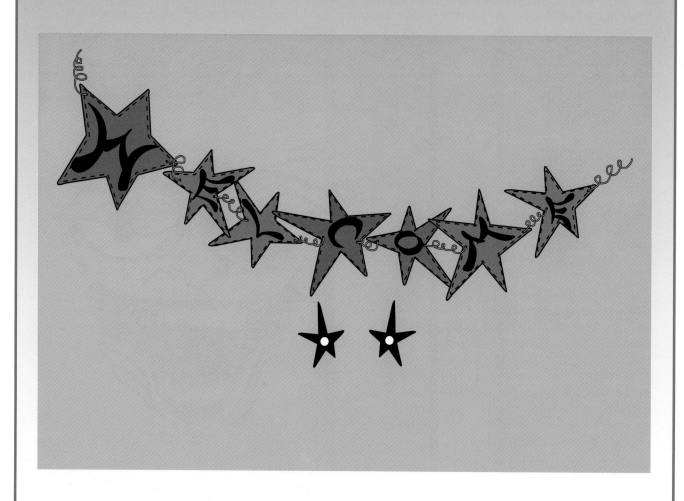

Werewolf
Pictured on page 31

Materials:
Acrylic paints: brown, flesh, ivory, yellow. Glue gun and glue sticks. Novelty items: fangs; hair, brown and white; latex skin. Sponge. Straight pins.

Painting:
Form latex skin into nose. Press in place on pumpkin. Paint nose brown with flesh nostrils. Paint pumpkin flesh. Paint and detail pumpkin face, referring to pattern. **Sponge** face with brown.

Decorating:
Hot-glue brown hair to pumpkin, referring to photograph for placement. Add white hair to form stripes. Attach fangs with pins.

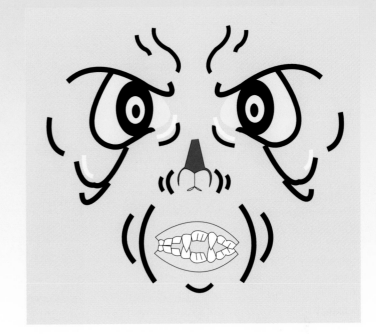

Grim Reaper
Pictured on page 32

Materials:
Acrylic paints: white, yellow. Crepe: black, 1/2 yd. Glue gun and glue sticks. Nails: (2). Novelty items: skeleton hand, hatchet. Spray paint: black.

Painting:
Spray pumpkin black. Paint and detail pumpkin face, referring to pattern.

Decorating:
Wrap and shape black crepe around face of pumpkin to form a hood. Hot-glue skeleton hand to side of face so it appears to be pulling hood back. Attach hatchet to back of pumpkin with nails.

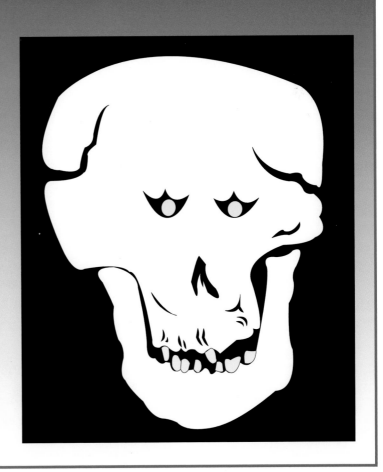

Turkey Candle Holder
Pictured on page 32

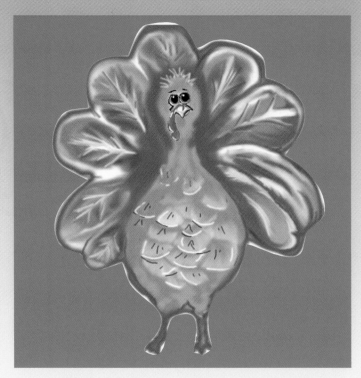

Materials:
Pumpkin candle holder: wooden. Acrylic paints: black, brown, dk. brown, med. brown, copper, gold, iridescent green, smoked pearl, dusty pink, lt. pink, red, dk. red, yellow, dk. yellow, lt. yellow, med. yellow, white. Candle: 8". Flow medium. Glaze: clear. Sealer: all-purpose. Sponge: small silk.

Painting:
Mix all-purpose sealer with black paint. Mix glaze and flow medium 1:1 and moisten candle with sponge. Sparsley **sponge** copper. Using same sponge without rinsing, **sponge** with lesser amount of gold. Rinse sponge. Sparsely **sponge** iridescent green. Thin iridescent green with flow medium and drip along top of candle. Referring to pattern and General Instructions, paint and detail turkey as follows: **base** - body med. brown; eyes white; irises brown; pupils black; beak med. yellow; gobbler red; **float** (shade) - feathers and outer body dk. brown; eyes med. brown; beak dk. yellow; gobbler dk. red; **float** (highlight) - tips of feathers and entire top edge of wings smoked pearl; beak lt. yellow; gobbler dusty pink; **line** - eyebrows, eyelashes, eyes, beak, gobbler, body, feathers and legs black; feathers and feet smoked pearl; **comma strokes** - beak white; gobbler lt. pink. Place candle in candle holder.

Snarling Man
Pictured on page 32

Materials:
Acrylic paints: black, black-green, white. Glue gun and glue sticks. Novelty chain. Rhinestones: (3).

Painting:
Mix black-green and white paints and wash over face of pumpkin, making edges darker. Dry thoroughly. Paint and detail pumpkin face referring to pattern.

Decorating:
Hot-glue rhinestones to pupils and one tooth. Wrap and drape chain around stem of pumpkin.

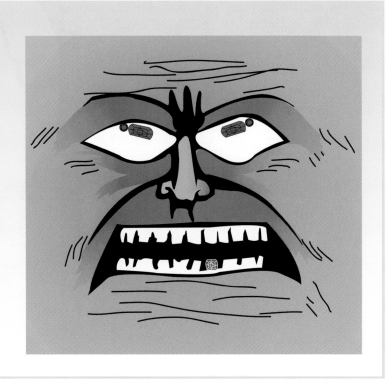

"Toadal" Spell
Pictured on page 33

Materials:
Pumpkin: compressed styrofoam. Acrylic paints: black, brown, lt. brown, lt. gray, green, bright green, dk. green, lt. green, magenta, dk. pink, lt. pink, dk. purple, bright red, dk. red, white, lt. yellow. Balls: wooden 3/4" (2 for eyes). Crackle medium. Egg: 2 1/2" wooden (cut in half for body). Glaze: glitter. Craft glue. Ribbon: 1/4"-wide lavender silk, 12". Varnish: clear.

Painting:
Base-coat pumpkin with dk. purple. Apply crackle following manufacturer's instructions. Mix bright red and lt. yellow 1:1. Paint as overcoat. **Dry-brush** with dk. red and lt. yellow. Paint stem green. **Dry-brush** stem using bright green to lt. yellow. Glue eyes on body to form toad. Glue toad to pumpkin. Referring to pattern and General Instructions, paint and detail toad as follows: **base** - body, legs and feet green (while paint is still damp, stroke legs and feet with lt. green); eyes white; irises brown; pupils black; spots dk. pink; **float** (shade) - mouth dk. green; outer spots magenta; **float** (highlight) - irises lt. brown; mouth lt. green; **stipple** - top of eyes and lids lt. gray; cheeks magenta then lt. pink; center of large spots lt. pink; **line** - eyelashes, eyes and mouth black; legs and large spots dk. green; **comma strokes** - pupils white; nose black; additional highlights in legs and feet lt. green; **dots** - white. Mix varnish with glitter glaze and brush onto toad as desired.

Decorating:
Tie ribbon into bow. Glue in place at right side of toad. Mix glitter varnish with glaze. Apply to inside edge of face on pumpkin and on toad.

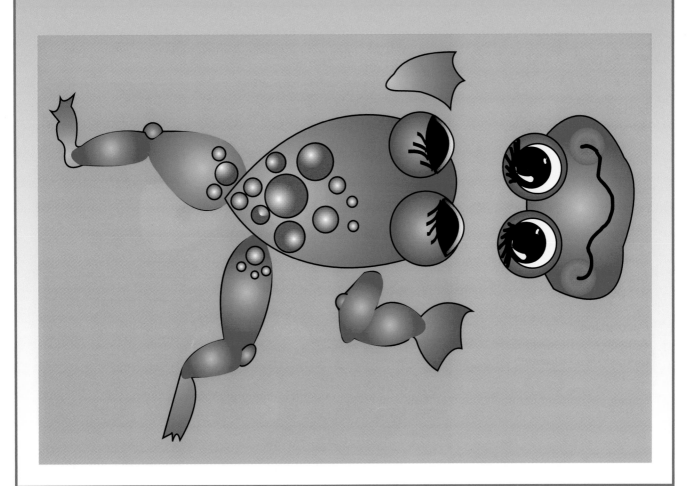

Gray Guy
Pictured on page 33

Materials:
Acrylic paints: black, charcoal, white. Glue gun and glue sticks. Novelty items: black spider, large; spider web. Straight pins.

Painting:
Mix charcoal and white with equal amount of water over face of pumpkin. Let dry thoroughly. Paint and detail pumpkin, referring to pattern.

Decorating:
Hot-glue spider to forehead. Pull and stretch spider web around pumpkin. Secure with pins.

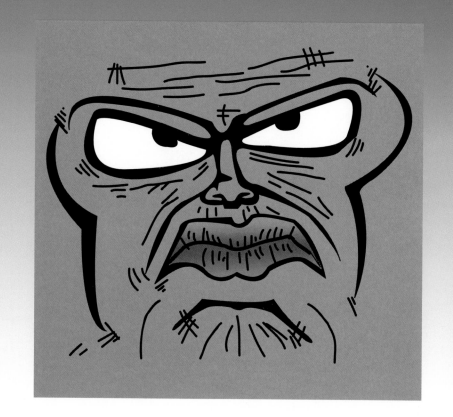

Witch Hazel
Pictured on page 33

Materials:
Acrylic paints: black, lt. green, dk. green, white. Novelty items: witch's nose; witch's wig. Straight pins. Witch's hat.

Painting:
Paint pumpkin dk. green. Paint and detail pumpkin face, referring to pattern.

Decorating:
Attach wig, hat and nose to pumpkin with straight pins.

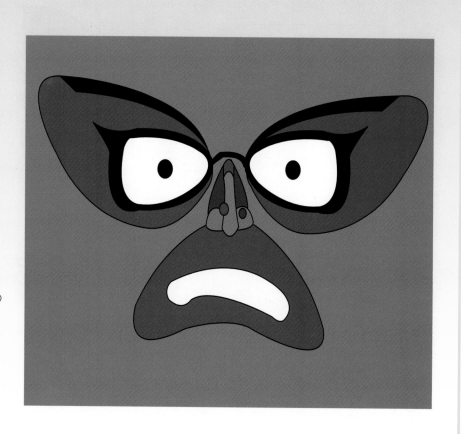

Oil Pan Pumpkin
Pictured on page 34

Materials:
Automotive oil pan. Acrylic paints: aqua, black, dusty blue, dk. dusty blue, dk. gray, bright green, teal green, dusty pink, lt. pink, purple, red, bright red, lt. red, dk. red, white, lt. yellow. Glue gun and glue sticks. Texture paste. Ribbon: purple net, 1-1/2 yds.

Painting:
Mix bright red and lt. yellow 1:1 for inside basecoat. Mix basecoat with texture paste 1:1 and paint inside of pan. Let dry thoroughly. **Slip-slap** center area, adding more lt. yellow. Mix bright green and teal green 1:1 for outside basecoat. Mix basecoat with texture paste 1:1 and paint outside of pan. Slip-slap outside, adding more bright green and lt. yellow. Dry thoroughly. Paint edge of pan where two colors meet with purple. Referring to pattern and General Instructions, paint and detail pan as follows: **base** - eyes white; irises dusty blue; pupils and mouth black; cheeks and nose red; **float** (shade) - eyes aqua; irises dk. dusty blue; cheeks and nose dk. red; **float** (highlight) - cheeks and nose dusty pink; pupils dk. gray; **line** - eyebrows, eyelashes, eyes, cheeks and nose black; **comma strokes** - eyes white; cheeks and nose lt. pink; **dots** - eyes white; cheeks and nose lt. pink.

Decorating:
Tie purple net ribbon under and around top lip of pan. Dab small amounts of hot glue to hold ribbon in place. Gently stretch to open bow loops and ribbon tails.

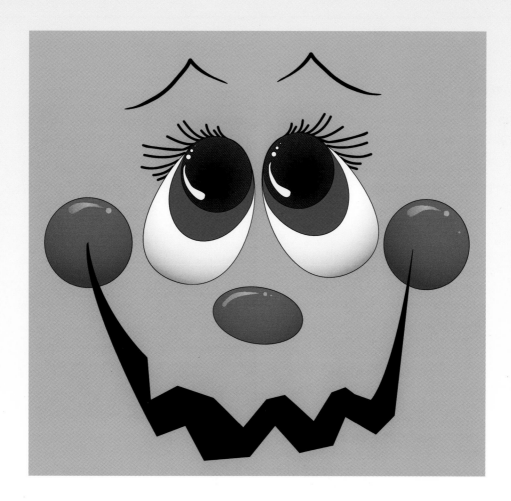

Rest in Peace
Pictured on page 34

Materials:
Pumpkin: compressed styrofoam. Acrylic paints: black, dk. gray. Foam core: 11" x 17". Glue gun and glue sticks. Craft knife. Leaves: silk (2). Leaf pick: autumn. Novelty eyes: large (2), small (4). Plasticote flexstone: gray. Screws: gold, wood (3).

Painting:
Use craft knife to cut out headstone from foam core. Spray with flexstone and allow to dry. Referring to pattern and General Instructions, paint and detail headstone as follows: **base** - cracks and lettering black; rub with finger to lighten areas in cracks; **float** (shade) - headstone dk. gray.

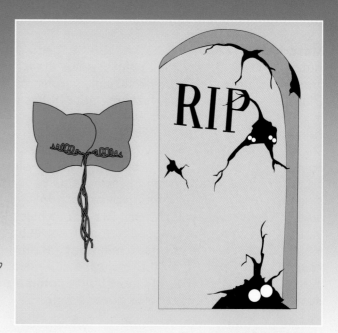

Decorating:
Hot-glue pairs of novelty eyes to painted cracks in headstone. Attach pumpkin to headstone using wood screws. Hot-glue silk leaves to base of pumpkin stem. Hot-glue silk autumn leaves in place so they look as though the wind blew them against the headstone.

Bats
Pictured on page 36

Materials:
Hubbard squash: small. Foam sheets: black, red, white. Craft glue. Glue gun and glue sticks. Pen: black felt marker. Spray paint: black. Styrofoam ball: 2". Wire: lightweight. Wire cutters.

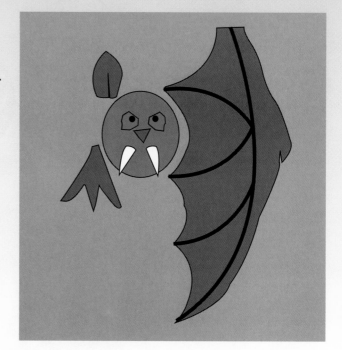

Decorating:
Cut styrofoam ball in half. Spray paint one half black for head. Glue head to front of squash. Cut two bat wings from black foam sheet. Cut two lengths of wire to fit the entire top edge of each wing, leaving an extra 1" at inside edge for attaching to squash. Referring to pattern for placement, draw bones on wings with black marker. Attach wings to squash and secure with hot glue. Shape as desired. Cut two eyes from red foam sheet. Draw a pupil in each eye with black marker. Hot-glue eyes onto head. Cut a small triangle from black foam sheet for a nose and craft glue onto head. Cut two fangs from white foam sheet and craft glue in place. Cut two feet from black foam sheet and craft glue feet to bottom of squash.

Punk Spider
Pictured on page 34

Materials:
Chenille: 24" lengths, black (6). Easter grass: white. Craft glue. Novelty items: eyes, large (2); eyelashes (2); spider, small black; spider web, small wire. Rhinestones: various sizes, multi-colored and shaped. Ribbon: 1/4"-wide white and black, 12" (2 each). Trim: 1-1/2"-wide black mesh. Hair spray: gold. Spray paint: black.

Carving:
Carve pumpkin, referring to pattern and General Instructions.

Painting:
Spray pumpkin black. Let dry thoroughly. Spray with gold hair spray. (Gold will become more transparent upon drying.)

Decorating:
Glue eyelashes to eyes. Glue eyes to pumpkin. Glue rhinestones around eyes and mouth and points of carving as desired. Glue Easter grass to top of pumpkin for hair. Glue black mesh to one edge of spider web for veil. Glue spider web to hair for hat. Glue spider onto web. Hold streamers together as one and glue onto pumpkin at side of web. Glue rhinestone over streamers where attached to pumpkin to form a hat pin. Tack three chenille lengths to each side of pumpkin for legs.

Wizard
Pictured on page 35

Materials:
Birdhouse gourd. Feather boa: white. Felt: 72"-wide blue, 3/4 yd. Foam sheets: green, yellow. Glitter: gold. Glue gun and glue sticks. Novelty items: eyes, wand. Permanent marker: black. Ribbon: 3"- wide gold with stars, 1/2 yd. Skewer stick. Stuffing. Styrofoam ball: 1".

Decorating:
Cut a 10" x 7-1/2" triangle from felt. Roll into a cone, hot glue seam and lightly stuff. Cut a 22"- diameter circle from felt for hat brim. Hot-glue cone onto brim. Wrap ribbon around base of hat and hot-glue in place, with seam at back of hat. Turn gourd so that neck becomes nose of wizard. Cut styrofoam ball in half. Hot-glue balls above nose. Hot-glue novelty eyes onto balls. Hot-glue hat onto head of gourd. Cut boa into four pieces and hot-glue three pieces around and under nose for beard and mustache. Cut two feathers from boa and hot-glue above eyes for eyebrows. Glue fourth boa piece under hat for hair. Cut two ears from green foam sheet. Draw swirls onto ears with black marker. Hot-glue ears to side of head. Cut stem off pumpkin. Cut one 24" -diameter circle from felt. Place over pumpkin for dress. Hot-glue gourd head to top of pumpkin. Cut two 6" squares from felt. Fold in half and hot-glue long edges together. Turn and hot-glue to sides of pumpkin for sleeves. Loosely stuff. Cut two hands from green foam sheet. Hot-glue hands inside sleeves. Cut two stars from yellow foam sheet. Hot-glue stars together with skewer stick in-between for a wand. Sprinkle star with glitter. Hot-glue wand to hand.

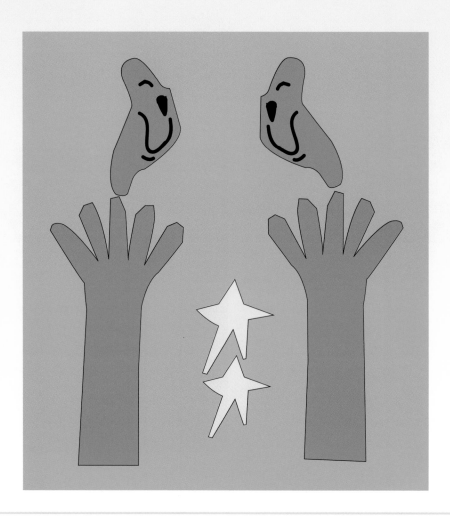

Vulture
Pictured on page 36

Materials:
Hubbard squash. Feather boa: black-and-white. Foam sheets: orange, white. Glue gun and glue sticks. Needle: hand-sewing. Novelty eyes (2). Nylon knee-high stocking: suntan. Stuffing. Thread: coordinating. Wire, 2/3 yd. Wire cutters.

Decorating:
Firmly stuff foot and loosely stuff leg of stocking to form head and neck of vulture. Hook one end of wire and insert wire up to foot of stocking for support. Cut wire, leaving wire 2" longer than neck. Insert end of neck wire into squash. Hot-glue stocking to squash. Wrap feather boa around neck twice, draping ends for wings. Hot-glue in place. Thread needle, knot and push needle through head. Pull tightly and secure to form indentations for eyes, referring to photograph for placement. Hot-glue eyes in indentations. Cut beak from orange foam sheet. Fold beak in half. Hot-glue tip of beak together and hot-glue beak to head. Cut two black feathers from boa. Hot-glue over eyes for eyebrows. Cut four toes from orange foam sheet. Fold toes as shown in Diagram. Cut four narrow triangles for claws from white foam sheet. Hot-glue claws on top of toes. Hot-glue toes to bottom of squash.

Pink Flamingo
Pictured on page 37

Materials:
Birdhouse gourd. Acrylic paint: orange. Dowel: 1/4" dia., 24". Feathers: bright pink. Foam sheets: orange, red, white, yellow. Glue gun and glue sticks. Permanent marker: black. Ribbon: 1-1/2"-wide pink with white polka-dot satin. Spray paint: pink.

Decorating:
Spray paint gourd. Let dry thoroughly. Cut three 1" x 3" rectangles from white foam sheet. Layer and hot-glue feathers to rectangles to form wings and tail. Cut upper and lower beak from orange foam sheet. Fold beak in half. Hot-glue tips of beak together. Cut tongue from red foam sheet. Hot-glue tongue to inside of beak. Hot-glue beak to head of gourd. Draw nostrils onto beak with black marker. Cut two eyes from yellow foam sheet. Draw pupils in eyes and outline eyes with black marker. Layer and hot-glue feathers to top of head and face. Hot-glue feathers in a ring around neck of gourd. Wrap ribbon around neck to form a tie and hot-glue in place. Cut dowel in half and paint each piece orange. Push dowels into gourd for legs.

Mummy
Pictured on page 38

Materials:
Glue gun and glue sticks. Novelty items: eyes, bloodshot (2); spider web netting. Pillowcase: white cotton. Spray paint: black.

Painting:
Spray pumpkin black.

Decorating:
Hot-glue eyes on pumpkin. Tear pillowcase into strips of various widths. Mummy-wrap pumpkin, securing strips with hot glue but also allowing some strips to hang loosely. Randomly string spider web netting over wrapped pumpkin.

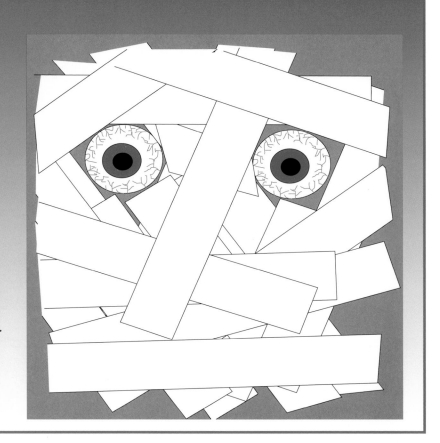

Space Alien
Pictured on page 38

Materials:
Acrylic paints: dk. blue, lt. blue, white. Garden glove: muslin. Straight pins. Stuffing.

Painting:
Mix dk. blue and white with equal amounts of water and apply to face of pumpkin. Paint and detail face, referring to pattern.

Decorating:
Stuff garden glove. Attach to side of pumpkin with pins.

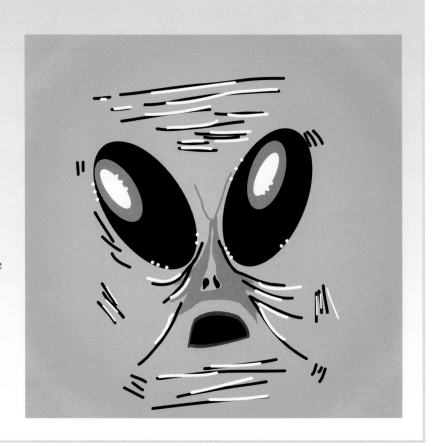

Jester
Pictured on page 38

Materials:
Acrylic paint: red. Feather boa: white. Foam sheets: red, white, yellow. Craft glue. Glue gun and glue sticks. Jester hat. Permanent marker: black. Straight pins. Styrofoam ball: 2". Styrofoam cone: 6".

Decorating:
Cut styrofoam ball in half for eyes. Draw pupils onto eyes with black marker. Hot-glue eyes onto pumpkin, referring to photograph for placement. Cut two triangles for under eyes from yellow foam sheet. Cut two narrow triangles from red foam sheet and craft glue into yellow triangles. Cut two eyebrow shapes from yellow foam sheet. Cut two narrow eyebrows from red foam sheet and craft glue into yellow eyebrow shapes. Hot-glue eyebrows and triangles in place. Cut 3" from top of styrofoam cone for nose. Paint nose red. Let dry thoroughly. Hot-glue nose to pumpkin. Cut lips from red foam sheet and teeth from white foam sheet. Trace mouth opening onto pumpkin and color in with black marker. Hot-glue teeth and lips in place. Cut feather boa to fit as hair and hot-glue in place. Attach jester hat with pins.

Scared
Pictured on page 39

Materials:
Acrylic paints: black, bright orange, white, yellow. Foam mount board: 12" x 12". Craft glue. Craft knife. Pencil. Sandpaper: 80 grit.

Painting:
Cut arms, eyes, mouth and nose from foam mount board. Sand edges. Paint and detail arms and facial features, referring to pattern.

Decorating:
Mark placement for facial features on pumpkin. Cut and remove 1/4" of pumpkin from marked features to inset foam mount board features. Secure features to pumpkin with glue.

Muslin Witch
Pictured on page 39

Materials:
Acrylic paints: black, green, orange.
Balloon: 12". Fabric: muslin, 2 yds.
Fabric dye: black. Fabric stiffener.
Fusible web: double-sided, 3/8 yd. Glue
gun and glue sticks. Sand: 2 cups. Twine:
thick, (1 ball).

Decorating:
Following manufacturer's instructions,
coat fabric with fabric stiffener. Fill
balloon with sand and carefully blow up
to about 10" in diameter. Set balloon in
center of 1 yd. of fabric. Wrap fabric up
around balloon and tie at top of balloon
with twine to form a pumpkin. Twist top
fabric into a stem. Allow stiffener to dry.
Pop balloon when dry. Paint pumpkin
orange, except for cheeks, eyes and
forehead. Paint these areas green. Paint
stem black. Cut one 4" x 10" piece of fabric.
Twist and roll fabric to form nose. Coat

with fabric stiffener and allow to dry. Cut a small piece of twine and coat with fabric stiffener. Hot-glue to nose for wart. Hot-glue nose to pumpkin. Dilute orange paint with water and paint nose. Following manufacturer's instructions, dye remaining fabric black and allow to dry. Cut two 13"-diameter circles from fabric and one from fusible web. Cut one 3"-diameter opening in center of each circle. Following manufacturer's instructions, fuse circles together. Coat with fabric stiffener. Slip over stem for hat brim. Make eyes and eyebrows from twine. Coat with fabric stiffener. When dry, paint eyebrows green and streak with black. Paint top of eyes green, bottom of eyes with diluted orange, and pupils black. Allow to dry and glue to face. Cut twine into appropriate lengths for hair and bangs. Fray twine and paint with streaks of black and green. Hot-glue hair under hat and to top of pumpkin. Cut one 36" x 5" strip from remaining dyed fabric. Tie around base of pumpkin.

Gourd Jack-O-Lantern
Pictured on page 39

Materials:
Basket: pumpkin-shaped with handle. Glue gun and glue sticks. Floral pick: peppers, garlic, autumn leaves. Ribbon: olive green lace, 3 yds. Wire. Wire cutters.

Decorating:
Secure floral pick to left side of basket handle with wire. Tie lace ribbon into bow. Secure bow with wire and attach to top of floral pick. Shape florist pick as desired.

Witches Hat and Small Pumpkins
Pictured on page 40

Materials:
Pumpkins: small compressed styrofoam latex with leaves (3). Acrylic paints: aqua, black, dk. gray, lt. pink, red, dk. red, white. Fabric: black-and-white polka-dot, 1/2 yd. Freezer paper. Glue gun and glue sticks. Ribbon: 1-1/2"-wide purple wire-edge, 3-1/2 yds. Sealer: all-purpose. Tissue paper (1 sheet). Wire: purple crinkle (1 pkg.). Witch's hat: small, black felt.

Painting:
Referring to pattern and General Instructions, paint and detail one pumpkin as follows: **base** - eyes and tooth white; irises and mouth dk. gray; pupils black; nose red; **float** (shade) - eyes and tooth aqua; mouth black; nose dk. red; **stipple** - cheeks red; **line** - eyebrows, eyelashes, eyes, tooth and under nose black; mouth red; **comma strokes** - eyes white; nose lt. pink; **dots** - eyes white.

Decorating:
Lay fabric on freezer paper. Brush all-purpose sealer onto fabric and allow to dry. Cut one 18" circle for the brim of the hat. Cut one 18" square for the top of the hat. Fold square into a triangle once, and then again. Make a curved cut to slightly round the bottom edge. Fold over a 1/2" edge and hot-glue to make a cone. Push a small piece of tissue paper inside for added body. Stand cone in center of circle. Turn out a 1/2" edge. Hot-glue in place. Loosely tie ribbon into large bow around crown. Hot-glue ribbon edge down to cover seam. Shape and bend cone. Set pumpkins in place. Arrange and shape ribbon tails around pumpkins. Hot-glue crinkle wire to top of painted pumpkin for hair. Paint witch's hat with white polka-dots. Hot-glue hat to pumpkin.

Dragon
Pictured on page 40

Materials:
Sweet meat squash: large. Chalk: green, yellow. Glue gun and glue sticks. Nylon knee-high stockings: off-white (4). Needle: hand-sewing. Rhinestones: round gold (2). Sequins: black (2). Spoon. Stuffing. Styrofoam balls: 1", 3". Thread: coordinating. Wire: 1-1/2 yds. Wire cutters.

Decorating:
Stuff toe of one stocking. Insert large styrofoam ball behind stuffing. Loosely stuff rest of stocking for neck of dragon. Cut wire the length of the neck. Insert wire up through neck and into ball for support. Thread needle, knot and push needle through head. Pull tightly and secure thread to form indentations for eyes. Repeat process for nostrils. Sew a gather stitch around nose. Gather and secure thread to form mouth. Push needle through head and carry thread over top of head three times to form nose ripples. Repeat process on underside of neck for a scaled appearance. From end of stocking, cut two 1" x 2" pieces. Sew bottom together on each piece. Turn. Stuff and sew opening closed to form eyelids. Cut small styrofoam ball in half for eyes. Gently flatten front of eyes with spoon. Glue a rhinestone to each eye. Hot-glue a sequin to each rhinestone for a pupil. Hot-glue eyes to indentations on head. Hot-glue eyelids above eyes. Rub green chalk over head and neck to color. Rub black chalk inside nostrils. (Use paintbrush to apply chalk in small areas.) Rub yellow chalk on underside of neck. Insert end of neck wire into squash. Hot-glue excess stocking onto squash. Turn second stocking inside out. Sew end into a tapered tail. Trim excess. Turn right side out and loosely stuff. Cut wire length of tail. Run wire up through tail. Insert end of wire into squash. Bend end of tail to coil. Hot-glue excess stocking onto squash. Rub tail with chalks to color. Measure 3" from toe of each remaining stocking and cut off. Stuff and sew closed for feet. Sew two indentations into each foot to form toes. Rub feet with green chalk. Hot-glue feet to bottom of squash. Stuff remaining stocking pieces and wrap around base of neck and tail. Hot-glue ends together then hot-glue to squash.

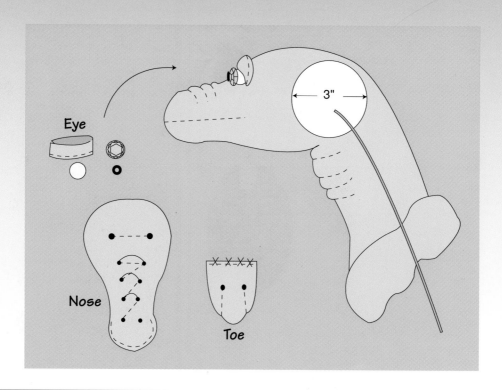

Truck
Pictured on page 41

Materials:
Acrylic paints: black, lt. blue, red, white. Disks: 2" wooden (4). Dowels: (1) 1/2"- (1) 1"-diameter. Drill and 1/2" drill bit. Foam mount board: 12" x 12". Glue: wood. Craft knife. Sandpaper: 80 grit. Saw. Screws: graffer. Screwdriver. Straight pins. Wheels: 4" wooden (4) Wire cutters.

Painting:
Paint and detail pumpkin, referring to pattern.

Decorating:
Cut 1/2" dowel into two appropriate lengths for axles. Drill holes for screws in ends of each dowel. Drill hole through center of each wood disk. Apply glue in screw holes and on ends of dowel. Screw disks to dowels. Apply glue to outer diameter of disk. Attach disk to wheels. Let dry. Paint axles and wheels black. Paint inside wheels lt. blue. Place pumpkin on its side and mark axle placement. Cut out groove for axle with craft knife. Measure and mark back area of pumpkin for truck bed. Carve truck bed. Measure and cut two pieces of mount board to fit for cab and bed of truck. Sand edges. Paint mount board black. Attach cab and bed to pumpkin with straight pins. Paint side edges of mount board in a dot pattern with red. Cut two 1-1/2" lengths from remaining 1/2" dowel. Insert a straight pin into each dowel. Clip off head of pin. Cut two 1/2" lengths from 1" dowel. Glue to smaller dowel for headlights. Paint sides of headlights red and paint tops white. Insert pin of headlights into pumpkin.

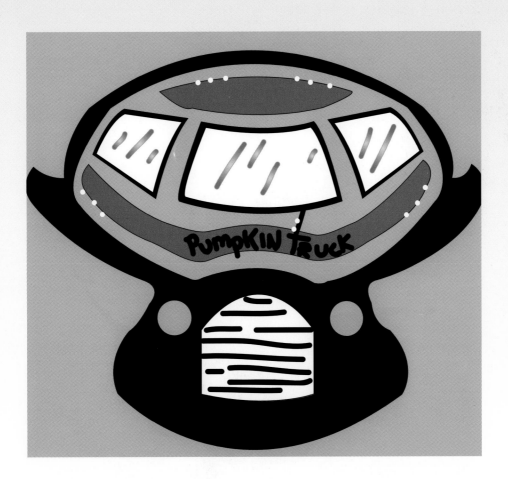

Haunting
Pictured on page 41

Materials:
Acrylic paints: black, dusty blue, brown, magenta, smoked pearl, purple, lt. purple, dk. red, white. Dowel: 1/4"-wide x 8". Glue gun and glue sticks. Varnish: gloss. Watercolor paper: 4-1/2" x 4-1/2", 400 lb. cold-pressed, white.

Painting:
Referring to pattern and General Instructions, paint and detail sign on smooth side of watercolor paper as follows: **base** - entire sign brown; **float** (shade) - entire sign black to create wood appearance and dry-brush with smoked pearl; **line** - lettering black; outline lettering smoked pearl; "X", underline and "!" lt. purple; **spatter** - entire sign black and lt. purple. Apply a coat of vanish to both sides of paper.

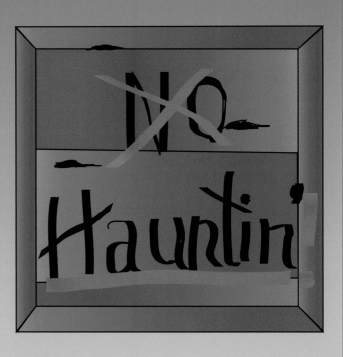

Paint and detail pumpkin face as follows: **base** - eyes white; irises dusty blue; pupils and "BOO" black; nose magenta; 3-D lettering magenta; **float** (shade) - eyes magenta; nose purple; **stipple** - cheeks dk. red; **line** - eyebrows, eyelashes and nose black; outer lettering magenta; inside lettering dusty blue; **comma strokes** - eyes and nose white; **dots** - eyes white.

Decorating:
Hot-glue paper sign to dowel. Hot-glue dowel to back of pumpkin.

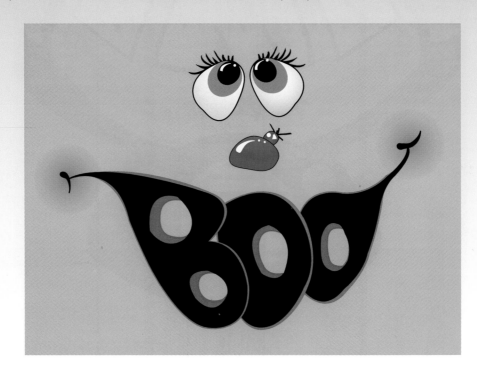

Monster
Pictured on page 41

Materials:
Hubbard squash. Acrylic paints: black, dk. green, magenta, orange, lt. pink, lt. purple, dk. red, white. Bolts: 3" metal (2). Glue gun and glue sticks. Mop cord: 5 yds. Spray bottle.

Painting:
Thin dk. red with water in spray bottle. Spray paint mop cord. Thin magenta paint with water and apply to face of squash. Referring to pattern and General instructions, paint and detail face as follows: **base** - eyes white; irises dk. green; pupils black; eyebrows orange; cheeks and nose lt. pink; **float** (shade) - eyes lt. purple; cheeks magenta; **float** (highlight) - cheeks, nose and mouth lt. pink; **line** - eyelashes, small strokes in eyebrows, eyes, nose and mouth black; **comma strokes** - cheeks, nose and mouth white; **dots** - eyes, cheeks and nose white.

Decorating:
Cut mop cord into 8" lengths. Hot-glue to top of squash. Insert bolts into side of squash, referring to photograph for placement.

Jack Frost
Pictured on page 42

Materials:
Pumpkins: compressed styrofoam (3 - small, medium, large). Acrylic paints: black, antique med. brown, red, white, yellow. Clothing: winter cap and pair of mittens. Fabric: 54"-wide wool plaid, 1/4 yd. Glue gun and glue sticks. Craft knife. Pen: med. pt. permanent black marker. Spray sealer: pearl finish. Stuffing. Twigs: 18" (2), 12" (1). Twine. Wood: 1/4" thick balsa, 5" x 9".

Painting:
Cut sign from balsa wood with craft knife. Paint sign with antique med. brown. Paint lettering with black. Paint and detail pumpkins, referring to pattern and photo for placement. Outline eyes, mouth and candy corns with black marker.

Decorating:
Referring to photograph, stack and hot-glue pumpkins together. Push 18" twigs into middle pumpkin for arms. Loosely stuff mittens and tie onto ends of arms with twine. Hot-glue hat onto pumpkin head. Wrap wool fabric around neck for scarf. Hot-glue 12" twig to back of sign. Hot-glue sign to palm of left mitten.

Fishbowl Pumpkin
Pictured on page 42

Materials:
Fishbowl: 6" diameter. Acrylic paints: aqua, black, dusty blue, gray, bright green, teal green, peach, red, dk. red, white. Glass and tile medium. Glue gun and glue sticks. Leaves: silk (3). Raffia: natural, 7/8 yd. Ribbon: black print, 1 yd.

Painting:
Mix each paint color with glass and tile medium 1:3. Referring to pattern and General Instructions, paint and detail fishbowl as follows: **base** - eyes white; irises bright green; pupils black; nose teal green; mouth red; **float** (shade) - eyes aqua; nose dusty blue; mouth dk. red; **float** (highlight) - pupils gray; nose aqua; mouth peach; **stipple** - cheeks red; **line** - eyebrows, eyelashes, eyes, nose and mouth black; **comma strokes** - eyes and nose white; mouth peach

Decorating:
Wrap raffia around bowl and tie a bow. Tie ribbon into bow. Hot-glue bow to center of raffia bow.

Fabric Pumpkin
Pictured on page 42

Materials:
Fabric: orange wool, 1/2 yd. Glue gun and glue sticks. Floral pick: berries. Leaves: latex. Raffia: natural, 1 yd. Sewing machine. Stem: 1 1/2"-diameter x 6". Stuffing. Thread: coordinating. Wire. Wire cutters.

Decorating:
Enlarge Pattern 200%. Cut six of pattern from wool fabric, transferring all markings. Pin two panels right sides together, matching notches. Sew a 1/4" seam along one side of panel. With right sides together, pin and sew a third panel to first two panels. Set aside. Repeat process with remaining three panels. With right sides together, pin and sew panel sets together, beginning and ending 1-1/2" from top. Clip curves and turn right side out. Stuff firmly. Turn top edge in 1/2". Whip-stitch 1-1/2" seams closed. Place stem into opening and hot-glue in place. Cut leaves and berries from stems. Hot-glue leaves on as a base and to fill most of the area. Tie raffia into bow and secure with wire. Hot-glue in place. Hot-glue berries where desired. Carefully pull open raffia to its complete width. Knot and "V"-clip ends.

top

grain

bottom

Pumpkin Wreath
Pictured on page 42

Materials:
Pumpkins: 7" coconut (2). Autumn leaves: latex. Eucalyptus stems: (6). Floral wire. Glue gun and glue sticks. Grapevine wreath: 18". Metallic paints: gray, emerald green, gold, red, topaz. Ribbon: 2 1/2"-wide burgundy/green/gold plaid wire-edge, 3 yds.

Painting:
Using one color at a time and muting each color with a drop or two of gray, paint plaids on pumpkins by floating paint in lines in an overlapping, criss-cross manner. Referring to photograph for placement, hot-glue pumpkins, leaves and eucalyptus stems to wreath. Tie ribbon into a multi-loop bow with 12" tails. Hot-glue bow underneath pumpkins and cascade ribbon tails through leaves.

Golden Pumpkin
Pictured on page 43

Materials:
Acrylic paints: metallic gold, dk. green. Bronzing powder: antique French. Gold leafing sheets: 1 pkg. Autumn leaf: large. Spray adhesive: industrial-strength.

Decorating:
Spray entire pumpkin with spray adhesive. Allow adhesive to set for 1-2 hours. Lay non-shiny side of gold leaf sheet on pumpkin. Rub sheet with fingers and remove sheet. Gold leafing will transfer onto pumpkin. Repeat process, overlapping leafing, until entire pumpkin is covered. Lightly brush bronzing powder over entire pumpkin, excluding stem. Lightly paint random areas of leaf with metallic gold. Hot-glue leaf to base of stem.

Painting:
Mix acrylic paints together 1:1 and paint stem, after all decorating is complete.

Gold Leaf Pumpkin
Pictured on page 43

Materials:
Papier mâché basket: pumpkin-shaped with handle. Acrylic paints: black, brown, burgundy. Brush: soft bristle. Cloth: soft, white. Floral pick: berries. Glue gun and glue sticks. Gold leaf adhesive. Gold leaf sheets (1 package). Leaves: autumn silk, separated (14). Retarder. Ribbon: brown ombré wire-edge, 3 yds. Sealer: all-purpose. Spray paint: copper, gold.

Painting:
Base-coat pumpkin basket with burgundy. Apply sealer to leaves with soft bristle brush. Brush under and on top of leaves, overlapping to cover paper mâché base. Let some leaves overlap above edge. Let dry thoroughly. Apply gold leaf adhesive to pumpkin according to manufacturer's instructions. Let dry until clear. Apply sheets of gold leaf, overlapping to ensure coverage. Let dry completely before using a soft cloth to rub and remove overlap and excess. Mix brown, black and burgundy 3:1:1 with retarder to consistency of whipping cream. Brush over surface, being certain to apply to detail. Wipe with a soft absorbent rag to remove excess. Wipe in one direction. Let dry thoroughly. Apply sealer. Lightly spray seven leaves with copper then gold paint.

Decorating:
Tie ribbon into a four-loop bow with 24" tails. Arrange and hot-glue leaves, bow and berries to left side of basket and handle, referring to photograph for placement. Weave ribbon tails around leaves and handle as desired. Hot-glue ribbon ends to basket.

Silver Pumpkin
Pictured on page 43

Materials:
Acrylic paints: metallic gold, dk. green. Glitter: 7 oz. tubes: gold, iridescent, white opaque. Craft glue. Glue gun and glue sticks. Mixing bowls. Newspaper. Rhinestones: 3/4" clear oval (4-5). Ribbon: 1-1/2"-wide sheer white with gold edging, 3-1/2 yds.; 1-3/8"-wide antique gold wire-edge, 3 yds. Spray paint: gold. Trim: 5/8"-wide white with gold edging, 5 yds.

Painting:
Spray entire pumpkin gold. Mix acrylic paints together 1:1 and paint stem.

Decorating:
Mix the three tubes of glitter together. Slightly dilute craft glue with water. Lay pumpkin on its side on newspaper. Using fingers, cover one side of pumpkin with glue. Sprinkle glitter onto pumpkin, gently pressing glitter into glue. Carefully turn pumpkin over and repeat process until entire pumpkin is covered. Set pumpkin upright and allow glue to dry thoroughly . Cut wire-edge ribbon into five 6"-8" lengths and seven 7"-12" lengths. Fold set of five ribbons in half sideways so inner edges touch. Shape folded ends of ribbons into points. Gently gather inner edge wires to form leaves. Twist wires around raw ends and turn under. Using both hands, twist set of seven ribbons until ribbon twists into itself to form tendrils. Cut trim into appropriate lengths to vertically fit around pumpkin. Glue trim to pumpkin. Hot-glue leaves and tendrils around stem of pumpkin. Glue rhinestones to several leaf tips and on pumpkin as desired. Make a multi-looped bow from sheer ribbon and hot-glue around stem and inbetween leaves and tendrils.

Copper Pumpkin
Pictured on page 43

Materials:
Acrylic paints: metallic copper, metallic gold, dk. green. Glue gun and glue sticks. Ribbon: 3/8"-wide metallic copper, 3 yds.; 2"-wide gold wire mesh, 1 yd.; 3"-wide sheer gold, 1-1/4 yds.; 3-1/8"-wide copper wire mesh, 3 yds. Scissors. Spray paint: gold. Spray varnish: glitter. Twigs.

Painting:
Paint entire pumpkin metallic copper. Mix metallic gold and dk. green paints together 1:1 and paint stem. Spray twigs with gold spray paint. Let dry and spray pumpkin with glitter varnish.

Decorating:
Cut copper mesh ribbon into appropriate lengths to vertically fit around pumpkin. Gently stretch ribbons open width-wise. Hot-glue ribbons in place at base of stem and under pumpkin until entire pumpkin is covered. Tie gold mesh and sheer gold ribbons into bows around stem. Curl metallic copper ribbon with scissors and drape around stem. Place bundle of twigs through bows.

Raffia Pumpkin
Pictured on page 44

Materials:
Pumpkin: seagrass. Acrylic paints: burgundy, copper, pale gold. Candle: 8-10" taper (color of choice). Floral pick: berries with autumn leaves, twigs and acorns. Glue gun and glue sticks. Leaves: silk. Raffia: burgundy, 3 yds. Sealer: all-purpose. Sponge: small silk. Wire. Wire cutters.

Painting:
Mix all-purpose sealer with burgundy 1:2. Basecoat candle. Sponge lightly with copper, allowing burgundy basecoat to show. Pick up pale gold in sponge and lightly sponge in a few areas.

Decorating:
Cut out stem from pumpkin and insert candle in hole. Hot-glue leaves around base of hole. Cut and separate floral pick. Tie raffia into bow and wire in place. Hot-glue individual sections of floral pick in desired locations. When pleased with arrangement, carefully spread out raffia bow.
NOTE: Candle is for display only, do not light.

Bean Bag Pumpkin
Pictured on page 44

Materials:
Fabric: autumn print, 1/3 yd. Beans: 2 lb. bag. Cording: 1/8"-wide metallic gold wire-edge, 1-1/2 yds. Dried leaves. Glue gun and glue sticks. Needle: hand-sewing. Pencil. Stem: 5" wooden. Thread: coordinating.

Decorating:
Enlarge Pattern 225%. Cut two from fabric. With a 1/4" seam allowance and right sides together, sew fabric pieces together, leaving a 2" opening at stem for turning. Turn right side out. Loosely fill with beans. Anchor stem in beans with hot glue. Hand-sew opening closed. Referring to photograph, tie cording around pumpkin bag as if wrapping a package, ending with 4" tails. Wrap tails around pencil to form spiral tendrils. Hot-glue leaves to base of stem.

Country Candle Holder
Pictured on page 44

Materials:
Berries: plastic (2 stems). Candle: 5" purple taper. Fabric: 2" x 2/3 yd. autumn print. Glue gun and glue sticks. Gyp (small bunch). Leaves: silk (2).

Decorating:
Remove stem and hot-glue candle in place. Tear fabric for frayed edges. Wrap fabric around stem and tie into bow. Angle-cut fabric ends. Hot-glue leaves in place, referring to photograph for placement. Arrange and hot-glue berries in place. Hot-glue gyp in place as desired for filler.
NOTE: Candle is for display only, do not light.

Spiced Pumpkins
Pictured on page 44

Materials:
Miniature pumpkins (2). Candies: Halloween. Cardboard work surface: 5" x 18". Cinnamon sticks: (6). Cranberries: dried (50). Glasses: margarita (2). Craft glue. Leaves. Needle: large-eyed. Ribbon: 1/4"-wide brown grosgrain, 1/2 yd. Straight pins. Twine: brown.

Ingredients:
Spices: nutmeg, pumpkin pie. Sugar. Packaged cheesecake mix. Eggs (2). Whipping cream.

Carving:
Cut lid in pumpkins and remove pulp and seeds, referring to General Instructions. Rinse and pat pumpkins and lids dry.

Decorating:
Cut cinnamon sticks to length of stem on glass. Cut one 3" piece of ribbon and pin, centered horizontally, to cardboard. Run a thick bead of glue along ribbon. Center and line up cinnamon sticks vertically across ribbon to measure 2-1/2". Let glue dry completely. Trim off excess ribbon. Remove pins from and lift sticks off cardboard. Wrap sticks around stems of glasses. Tie twine into a bow around sticks. Cut one 50" length of twine. Thread needle and double the twine. Leaving a 9" tail, make a knot. Thread on dried cranberries for about 12". Tie 9" tail of the threaded cranberry strand around stem, adding or subtracting cranberries to reach top of glass stem. Loosen wrap and make a knot at end of cranberries. Cut off twine, leaving a 9" tail at top. Wrap tightly again. Tie a bow with twine at top and bottom.

Food Preparation:
Fill bottom of glass with Halloween candies. Mix packaged cheesecake mix according to directions. Fold in 1/2 cup of whipping cream and 1 tsp. pumpkin pie spice. Spoon into pumpkins. Refrigerate for two hours. Brush leaves with egg whites and sprinkle with sugar. Place pumpkins in top of glasses. Garnish with whipping cream, nutmeg and sugared leaves.

Fresh Flowers in a Pumpkin
Pictured on page 45

Materials:
Fresh flowers and foliage: campanile (3 stems), leather leaf (10 stems), purple mums (1 stem), safflower (1 stem), sunflowers (9). Floral tape. Floral oasis: 3" x 6", soaked. Wire. Wire cutters.

Decorating:
Carve an opening in top of pumpkin. Remove seeds and pulp. Fill with water. Cut oasis to tightly fit opening. Secure oasis with floral tape. Cut wires the length of sunflowers. Bend one end of wire into a hook. Run wire down center of sunflowers and pull tight. Arrange flowers and foliage, referring to photograph. Keep water on oasis for longest possible flower life.

Sunflower
Pictured on page 45

Materials:
Acrylic paints: dk. brown, lt. brown, orange, yellow. Sunflower bouquet: artificial. Wire cutters.

Painting:
Paint and detail pumpkin, referring to pattern.

Decorating:
Cut artificial stems of sunflowers to 1-1/2". Insert stems into pumpkin as desired.

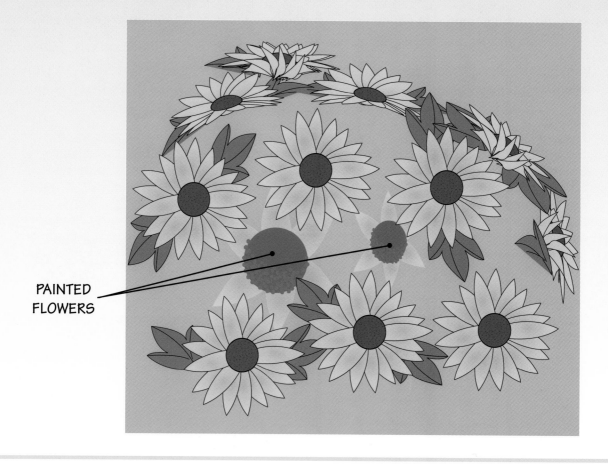

PAINTED FLOWERS

Leaves
Pictured on page 45

Materials:
Floral pick: berries, autumn flowers, autumn leaves, small gourds.

Carving:
Carve pumpkin, referring to pattern and General Instructions.

Decorating:
Insert end wires of floral picks into pumpkin in decorative pattern as desired.

House
Pictured on page 45

Materials:
Acrylic paints: dk. blue, lt. blue, burgundy, yellow. Foam mount board: 10" x 42", 1/2" thick. Glue gun and glue sticks. Craft knife. Moss. Ruler. Tape: masking. Sandpaper: 80 grit.

Painting:
Remove stem. Set aside. Paint and detail pumpkin, referring to pattern.

Decorating:
Use craft knife to cut foam mount board into two 7-3/4" x 1- 3/4" squares (roof), two 10" x 5-1/2" triangles (gable supports) and two 2" x 1/2" rectangles (window boxes). Roof components may have to be adjusted due to pumpkin size. Smooth edges with sandpaper. Angle longest edges of roof pieces to form a pitched roof to fit pumpkin. Hot-glue roof pieces. Hold together with masking tape. Paint roof burgundy. Let dry. Paint pattern on edge of roof yellow. Paint gable supports and window boxes dk. blue. Let dry thoroughly. Paint heart on front

gable support with white. Let dry thoroughly. Hot-glue gable supports to roof. Hot-glue window boxes to pumpkin. Hot-glue moss to top of window boxes. Hot-glue pumpkin stem to roof for chimney.

Billy Bob Bat
Pictured on page 46

Materials:
Acrylic paints: aqua, black, dusty blue, brown, dusty blue, dk. gray, lt. gray, dk. green, magenta, dusty pink, purple, lt. purple, dk. red, white. Glue gun and glue sticks. Ribbon: 1-1/2"-wide black print wire-edge, 1 -3/4 yds. Varnish: gloss. Watercolor paper: 4" x 12" , 400 lb. cold-pressed, white. Wire: copper, 12".

Painting:
Cut bat from watercolor paper. Referring to pattern and General Instructions, paint and detail bat on smooth side of paper as follows: **base** - body dk. gray and dry-brush with lt. gray; eyes and teeth white, irises brown; pupils black; nose and mouth dk. red; bow aqua; **float** (shade) - eyes aqua; bow dusty blue; outer wings, ears, eyes, nose, mouth, teeth and under bow black; **float** (highlight) - nose and mouth white; bow white; **line** - eyelashes and eyes black; **comma strokes** - eyes and bow knot white; **dots** - eyes, nose and bow knot white. Apply a coat of varnish to both sides of paper. Bend and shape paper while still damp. Let varnish thoroughly dry. Apply a second coat of varnish and further bend and shape paper as desired.

Paint and detail pumpkin face as follows: **base** - eyes white; irises dk. green; pupils black; nose lt. purple; **float** (shade) - eyes magenta; nose purple; **float** (highlight) - nose magenta; **line** - eyebrows, eyelashes, eyes, nose and mouth black; **comma strokes** - eyes white; nose dusty pink; **dots** - eyes white.

Decorating:
Hot-glue bat to wire. Insert wire into base of pumpkin stem. Tie ribbon into a double-loop bow with 9" tails. Hot-glue ribbon to top of pumpkin. Bend and curl ribbon tails.

Metric Conversions

INCHES TO MILLIMETRES AND CENTIMETRES

MM-Millimetres CM-Centimetres

INCHES	MM	CM	INCHES	CM	INCHES	CM
1/8	3	0.9	9	22.9	30	76.2
1/4	6	0.6	10	25.4	31	78.7
3/8	10	1.0	11	27.9	32	81.3
1/2	13	1.3	12	30.5	33	83.8
5/8	16	1.6	13	33.0	34	86.4
3/4	19	1.9	14	35.6	35	88.9
7/8	22	2.2	15	38.1	36	91.4
1	25	2.5	16	40.6	37	94.0
1 1/4	32	3.2	17	43.2	38	96.5
1 1/2	38	3.8	18	45.7	39	99.1
1 3/4	44	4.4	19	48.3	40	101.6
2	51	5.1	20	50.8	41	104.1
2 1/2	64	6.4	21	53.3	42	106.7
3	76	7.6	22	55.9	43	109.2
3 1/2	89	8.9	23	58.4	44	111.8
4	102	10.2	24	61.0	45	114.3
4 1/2	114	11.4	25	63.5	46	116.8
5	127	12.7	26	66.0	47	119.4
6	152	15.2	27	68.6	48	121.9
7	178	17.8	28	71.1	49	124.5
8	203	20.3	29	73.7	50	127.0

YARDS TO METRES

YARDS	METRES	YARDS	METRES	YARDS	METRES	YARDS	METRES	YARDS	METRES
1/8	0.11	2 1/8	1.94	4 1/8	3.77	6 1/8	5.60	8 1/8	7.43
1/4	0.23	2 1/4	2.06	4 1/4	3.89	6 1/4	5.72	8 1/4	7.54
3/8	0.34	2 3/8	2.17	4 3/8	4.00	6 3/8	5.83	8 3/8	7.66
1/2	0.46	2 1/2	2.29	4 1/2	4.11	6 1/2	5.94	8 1/2	7.77
5/8	0.57	2 5/8	2.40	4 5/8	4.23	6 5/8	6.06	8 5/8	7.89
3/4	0.69	2 3/4	2.51	4 3/4	4.34	6 3/4	6.17	8 3/4	8.00
7/8	0.80	2 7/8	2.63	4 7/8	4.46	6 7/8	6.29	8 7/8	8.12
1	0.91	3	2.74	5	4.57	7	6.40	9	8.23
1 1/8	1.03	3 1/8	2.86	5 1/8	4.69	7 1/8	6.52	9 1/8	8.34
1 1/4	1.14	3 1/4	2.97	5 1/4	4.80	7 1/4	6.63	9 1/4	8.46
1 3/8	1.26	3 3/8	3.09	5 3/8	4.91	7 3/8	6.74	9 3/8	8.57
1 1/2	1.37	3 1/2	3.20	5 1/2	5.03	7 1/2	6.86	9 1/2	8.69
1 5/8	1.49	3 5/8	3.31	5 5/8	5.14	7 5/8	6.97	9 5/8	8.80
1 3/4	1.60	3 3/4	3.43	5 3/4	5.26	7 3/4	7.09	9 3/4	8.92
1 7/8	1.71	3 7/8	3.54	5 7/8	5.37	7 7/8	7.20	9 7/8	9.03
2	1.83	4	3.66	6	5.49	8	7.32	10	9.14

INDEX